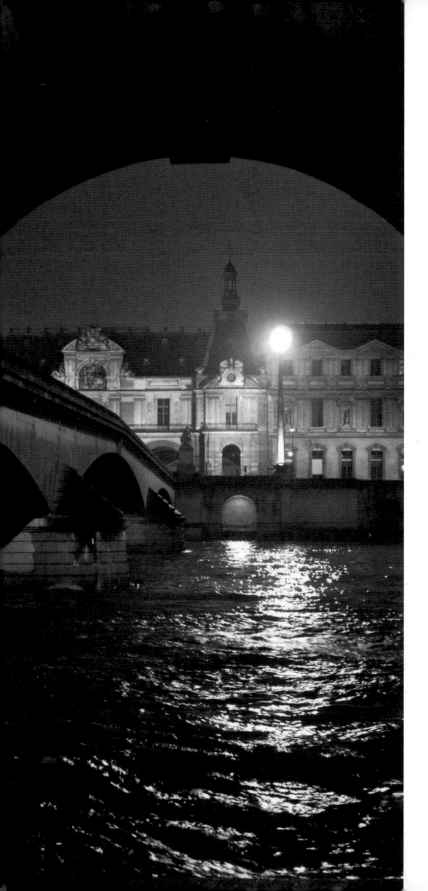

Hemingway's Paris

- A Writer's City in
Words and Images -

Robert Wheeler

YUCCA

Yucca Publishing books may be purchased in bulk at special discounts for sales promotion, corporate gifts, fund-raising, or educational purposes. Special editions can also be created to specifications. For details, contact the Special Sales Department, Yucca Publishing, 307 West 36th Street, 11th Floor, New York, NY 10018 or yucca@skyhorsepublishing.com.

Yucca Publishing is an imprint of Skyhorse Publishing, Inc.®, a Delaware corporation.

Visit our website at www.yuccapub.com.

10 9 8 7 6 5 4 3 2

Library of Congress Cataloging-in-Publication Data is available on file.

Cover design by Yucca Publishing
Cover photo © Robert Wheeler

Print ISBN: 978-1-63158-113-7
Previous ISBN: 978-1-63158-043-7
Ebook ISBN: 978-1-63158-053-6

Printed in China

Dedication

This book is lovingly dedicated to my wife, Katherine Gladney Wheeler . . . my Hadley.

Contents

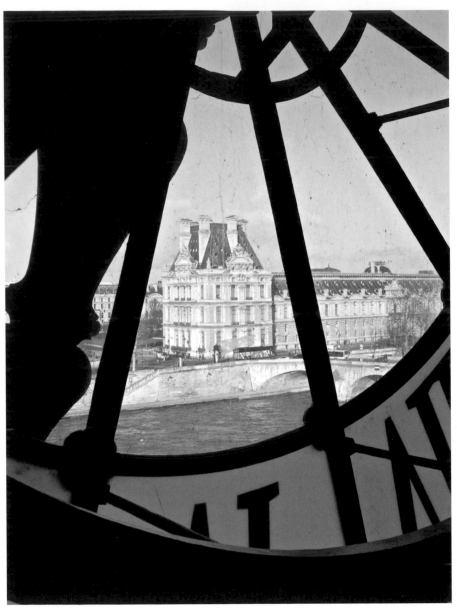

Musée d'Orsay

Foreword
By Jenny Phillips

In *Hemingway's Paris*, Robert Wheeler's photographs transport the viewer back to Ernest Hemingway's early formative years as a young writer living in Paris. Wheeler refers to his photographs as "lonely vignettes of black and white." When looking at them, one can't help but understand the influence those scenes had upon Hemingway.

The very places in which Hemingway lived, worked, and walked are those that now hold his haunting presence. A sense of place, of physical surrounding, became central to his writing style, and it was in Paris that he honed his craft of observing, focusing, and knowing through direct, personal experience. Wheeler's photographs are laden with an aura of loneliness, isolation, and personal struggle, reflecting Hemingway's commitment to "write the truest sentence that you know."

A Moveable Feast, written when Hemingway was an old man remembering the Paris years, can be read while gazing at Wheeler's photographs, bringing alive the significance of context, of weather and of mood upon Hemingway's imagination. The black and white of the photographs lend themselves to a sense of cold, of winter, of black trees framed against a white sky, of hurrying to find refuge in a warm and lighted café or room.

Wheeler captures Hemingway's view from his window looking out over the rooftops of Paris toward the Panthéon, itself a monument to great writers. It framed his view of Paris while he worked and wrote. "Up in that room I decided that I would write one story about each thing that I knew about," he wrote. "I was trying to do this all the time that I was writing, and it was good and severe discipline."

Another photo is of Hemingway's stairs to his writing room. The view is from above, looking straight down

i

as the stairs fold upon themselves like a cascading geo-metric design. A dramatic use of light and shade on the wooden balustrade lends an atmosphere of spirituality. The descending stairway represents Hemingway's path to freedom from writing each day as he went out into the Paris streets. "Going down the stairs when I had worked well, and that needed luck as well as discipline, was a wonderful feeling and I was free then to walk anywhere in Paris," he wrote. Once he was free for the day, Hemingway crisscrossed the streets, imprinting the sights, sounds, smells, and atmosphere of Paris in the 1920's. These memories were stored in notebooks and in his subconscious mind, waiting to be drawn upon over the years whenever he wrote.

In Paris, Hemingway discovered that certain cafés were conducive to good, clear writing. He could be alone while in the company of others as he sat and observed and took notes. In a studious and sensually alive state of being, he looked for fresh material for his writing. Wheeler's photos of Le Bistrot St. Honoré and the Salon de Thé on the Île St. Louis offer a beckoning warmth combined with a quality of emptiness and solitude.

"The blue-backed notebooks, the two pencils and the pencil sharpener, the marble-topped tables, the smell of early morning, sweeping out and mopping, and luck were all you needed."

Although he may have been writing about Michigan, the weather outside the café would be drawn into his story. Hemingway seemed to always be waiting for the right time to write about a place, forestalling the writing until he felt ready to deeply understand the place. "Maybe away from Paris I could write about Paris as in Paris I could write about Michigan," he says in *A Moveable Feast*. "I did not know it was too early for that because I did not know Paris well enough."

My grandfather, Max Perkins, who was just beginning his career as a Scribner's editor and would eventually nur-ture a whole new generation of American writers, sought

out Hemingway after a tip from Scott Fitzgerald who had befriended him in Paris. "This is to tell you about a young man named Hemmingway [sic], who lives in Paris. I'd look him up right away. He's the real thing."

After a brief meeting in the Scribner's office in New York, Perkins agreed to publish *The Sun Also Rises*, although he had not yet seen even a word of the book. It was only a partially written manuscript lying in a trunk in Austria. But Perkins had a hunch about Hemingway, an instinct for discovering great literature. He immediately gave him a contract and a $1500 advance.

In the spring of 1926, after months of waiting, the completed manuscript finally arrived. Perkins was stunned by the feel and power of the book. He wrote Fitzgerald, "The ms. wriggles with vitality. You recall scenes as if they were memories. You recall people as hard and actual as real ones."

The Sun Also Rises was written in the streets and rooms and cafés of Paris. Wheeler's photographs of Hemingway's Paris are a gritty illustration of what Perkins saw in Hemingway's writing. When Hemingway left Paris in 1928, in search of a new place in which to live and write, he transplanted himself to a vastly different world of bright light, tropical heat, and vivid colors. He moved first to Key West and then to Cuba, where he spent the last third of his life. In this fresh context, fishing and the blue waters of the Gulf Stream became the passion that drove his writing.

A Farewell To Arms was written in Key West before Hemingway was ready to write about the new place. But he was already observing and taking notes. By 1939, he was preparing for the story that was to become *The Old Man and the Sea*. In a letter to Perkins, he wrote, "I am going out with old Carlos in his skiff so as to get it all right. Every thing he does and every thing he thinks in all that long fight with the boat out of sight of all the other boats all alone on the sea. It's a great story if I can get it right."

By the late 30's and through the 40's, the Paris years of Wheeler's photographs lay dormant within Hemingway's mind. He would go back to this much later in his life. He had discovered another place for his writing, and a whole new life developed to support the need to write while living in Cuba. Like Wheeler's visits to Paris to document the Hemingway places, I have had a similar experience in Cuba visiting the places in which he wrote and lived. I have gazed through the windows that framed Hemingway's view while he did some of his greatest writing.

Hemingway lived at the Ambos Mundos Hotel while he was first writing *For Whom the Bell Tolls*, his novel about the Spanish Civil War. The view from his window is one of hot, sun-baked red tile roofs and the blue waters of the Havana Harbor. Although he was not yet writing about fishing in the Gulf Stream, he was readying himself for his last great novel, *The Old Man and the Sea*.

Hemingway's final refuge for writing was in a country estate outside Havana, Finca Vigia. It was in this place that he felt ready to write *The Old Man and the Sea* while standing on a kudu skin next to a sun filled corner window. As in Paris, he would not allow himself to walk out into the world each day until he was satisfied that he had written well. Although a tower room was built to provide him with a place of stillness and silence, he chose instead to write in a room in which he felt connected to people and a sense of easy access to freedom when he was finished for the day.

Although Paris and Cuba are visually and culturally contrasting places, they are like bookends on Hemingway's life as a writer. The habits he formed in Paris to construct a place in which he could write–one that was set apart but also connected to the sights and sounds of people–stayed with him throughout his life. A solitary journey through Robert Wheeler's photographs allows an understanding of the need for such a place.

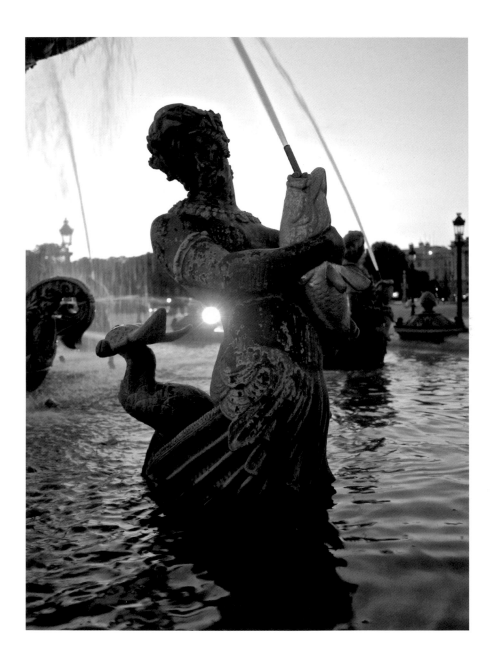

La Fontaine Medici

Introduction

Years ago, when I read for the first time Ernest Hemingway's *A Moveable Feast*, in my mind's eye, his story presented itself in lonely vignettes of black and white. Each chapter, or *sketch*, as he referred to them, represented an older Hemingway trying desperately to write his own truth about his years in Paris with his first wife, Hadley.

I have visited Paris many times over the years to try to discover the city that, more than any other, shaped Hemingway's writing style. With each trip, I moved closer to seeing Hemingway's Paris and closer to understanding this complex man and iconic figure.

While walking the avenues, boulevards, gardens and the pathways of Paris, I began to see why this place, above all others, was the perfect setting for Hemingway's craft to flourish. Being far from family and friends on these personal journies, I also began to feel a hint of the loneliness and heartbreak Hadley must have felt as her marriage to Hemingway shattered.

Hemingway's final act in his prolific life was the writing of *A Moveable Feast*, his memoir. A memoir filled with clarity yet deeply shrouded in despair. This would be the final piece of writing he would work on before taking his life on July 2, 1961. In *Feast*, Hemingway returned to the city he loved most, Paris. It returned him to the friends and influences who helped form his modernist sensibilities, and it returned him to a time in his life that, more than any other, inspired him to create. It was Paris, too, that returned him to the woman he loved most, Hadley.

Inspiration. Craft. Influence. And love. These were the four aspects, at the end of his life, that Ernest Hemingway felt he had lost for good.

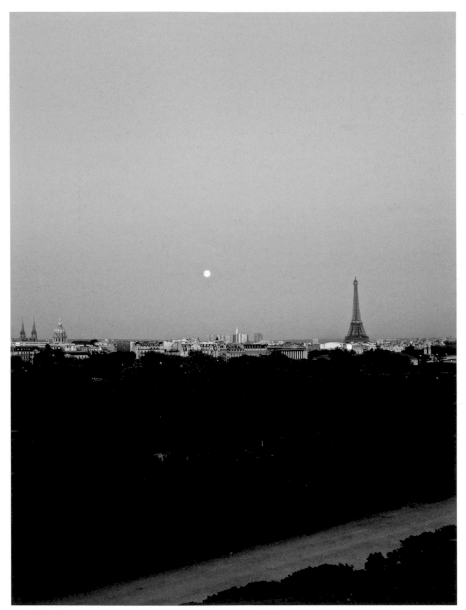

Paris landscape

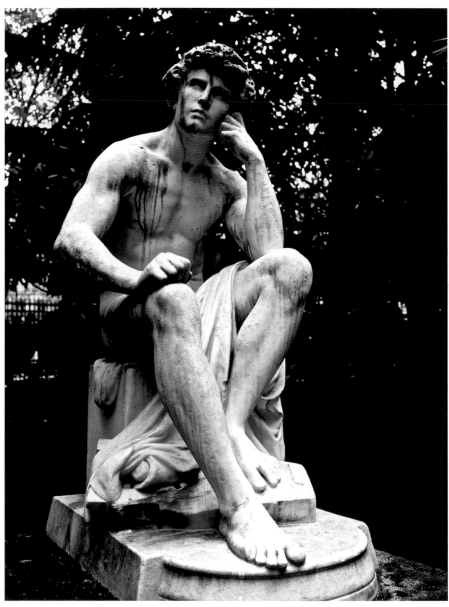

Jardin du Luxembourg

I

Inspiration

Paris, *La Ville-Lumière*, or *The City of Light*, has for centuries been a beacon for the world's most visionary. Some of the greatest artists ever known have lived and worked within the twenty arrondissements that spiral outward from the Louvre Museum to the Ménilmontant. American expatriate writers F. Scott Fitzgerald, Gertrude Stein, and of course Ernest Hemingway, along with French masters such as Émile Zola and Marcel Proust have sought inspiration here. There is a rich and profound feel to this city. From its history, through its architecture, to its culture, Paris has become the backdrop in which creative and artistic people seek, and more often than not, are able to find endless inspiration. Ernest and Hadley Hemingway, a young married American couple, arrived in Paris in December of 1921 aboard the *Léopoldina*. With his determination to become a great writer and her small trust fund to live upon, they began their journey together . . . a journey filled with love and loss.

Early in the morning, on cold, grey days in the 1920s, a young Ernest Hemingway would walk along the Quai St. Michel and quietly observe the booksellers setting up for the day. With the Notre Dame standing watch over their stalls upon the Île St. Louis, these sellers came to know Hemingway and, being a regular customer, he came to know them. From Left Bank hotels and from the ships that came into the city, they would find and hold properly bound books for Hemingway that were written in English, as he had not yet learned French.

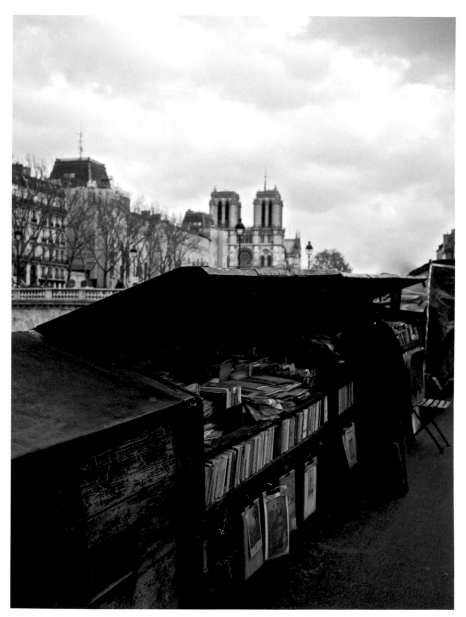

Bookstall along Seine

Along the avenues and back streets, and throughout the city, the small market owners would carefully present their lovely sustenance and freshest wares in a living still life. Walking along these streets toward his apartment on the Left Bank, Hemingway would often avoid these *épiceries*, noting that hunger was good discipline that would serve only to sharpen his senses. He believed that everything–every painting, every sculpture, every piece of architecture–was more beautiful and more clear if he were belly-empty and hollow-hungry.

Left Bank market

Hemingway's walks from the Musée Rodin toward the Jardin du Luxembourg along rue de Varenne were filled with layers of inspiration. Simple archways became frames from which to view the magnificence of the city. Solitary walks down streets with little activity are small gifts that present themselves to an artistic spirit. Hemingway would enter these poetic images into his memory and experiences, which would then become part of his life and future stories.

Along Rue de Varenne

The invitation would always be there, a cozy neighborhood café that would await Hemingway's presence. Warmly lit exteriors with their small tables spilling out onto the walkways would inspire him to stay and write for hours. As night fell upon this city, Hemingway would sit and reflect on his observations *of* and participation *in* this new place—this city where the light of Modernism shone brightly, beckoning artists from around the world to make Paris their own, and to make all things new.

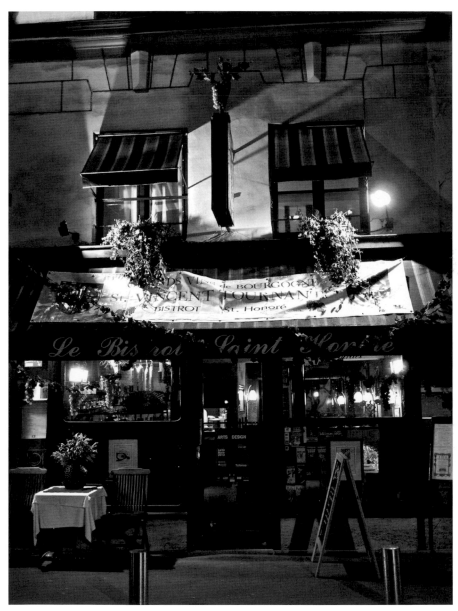

Le Bistrot St. Honoré on rue Gomboust

There is no looking down in Paris with the soft beige of the famous architect Baron Haussmann's façades. Hemingway's own work, the characters in ink upon his pages, in some way, must have been inspired by this architecture. The smooth, clean look of stone with black iron rails. The way the sun rises and sets upon them—turning them a pearl white in the morning light, while early evening and sunset welcome a blanket of pink. Simple and emotional, not unlike Hemingway's own prose.

Haussmann façade

The Jardin du Luxembourg is at its most extraordinary in winter. Hemingway believed the Jardin was more significant set against the heaviness of cold. Once stripped of its bloom, it became easier to focus on the beauty of the park itself. Hemingway wrote that a piece of him died each year when the leaves in Paris fell from the trees and the branches were barren. Like this photograph of the sculpture of *The Actor*, Hemingway himself evolved into one—a man with a public persona that differed somewhat from his true nature. Hemingway's romantic and sensitive side has always played a lesser role to the critics who never experienced the man and writer who lived, loved, learned and worked in Paris.

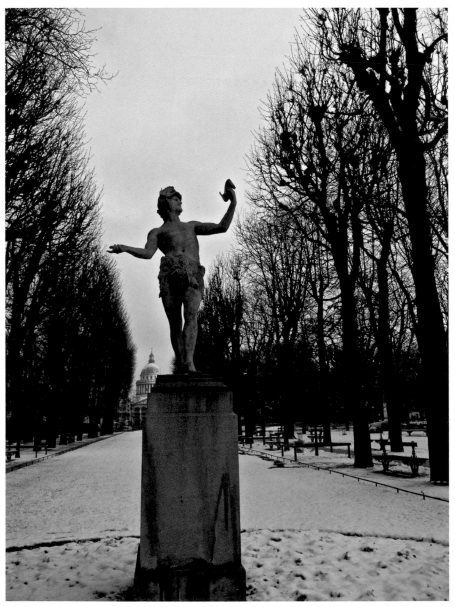

The Actor Jardin du Luxembourg with Panthéon

So much happens and many, including Hemingway, would agree that much of life is experienced outdoors in Paris. In his eyes, the concrete and cobblestone pathways that cascade down to the river were filled with as much richness and imagery as were the great museums. Hemingway found it was easier to think through the complexity of his work while he walked along the historic and inspiring passageways that line the banks of the reflective Seine.

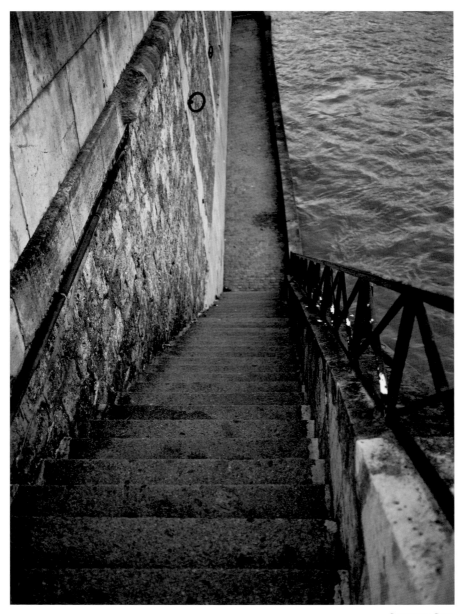

Stairway to Seine

Walking up his apartment stairwell at 74 rue Cardinal Lemoine, it was understandable for Hemingway to feel lonely after spending time alone with his work and its required intensity. Living in Paris, a city full of life and noise and happenings, one can still, at times, feel lost in anonymity. The city, powerfully alive on the streets, can appear empty when looking out over the rooftops. Hemingway used this vantage point from which to examine, gather, and express his thoughts. Writing is, after all, a lonely pursuit.

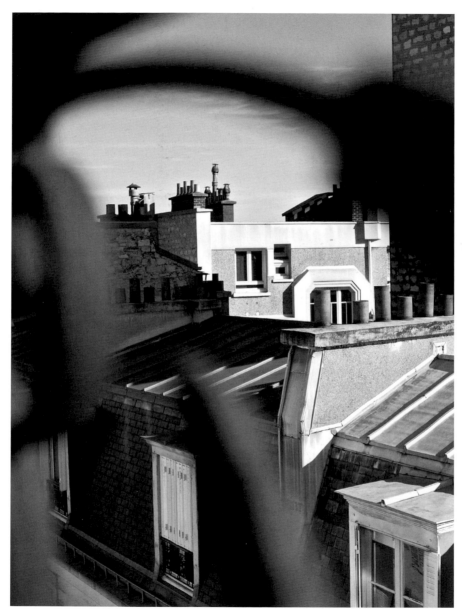

View from stairwell window 74 Rue Cardinal Lemoine

In the confines of the Panthéon reside the spirits of those French writers who reached the pinnacle of their artistic endeavors. A twenty-two year old Ernest Hemingway, living on the Left Bank, would walk by this monument and be awed and enlivened by the knowledge of the legacy of its occupants. Émile Zola, Victor Hugo, Voltaire–these were, in his mind, competitors. Hemingway, in the early years in Paris, having not yet produced a novel, was still working tirelessly on getting true, impressionistic paragraphs right. Each sentence mattered deeply to Hemingway and to sustain such acrid prose consumed him. Yet he was hopeful, if not confident, that he would one day live up to the significance and legacy of those who rest within the Panthéon.

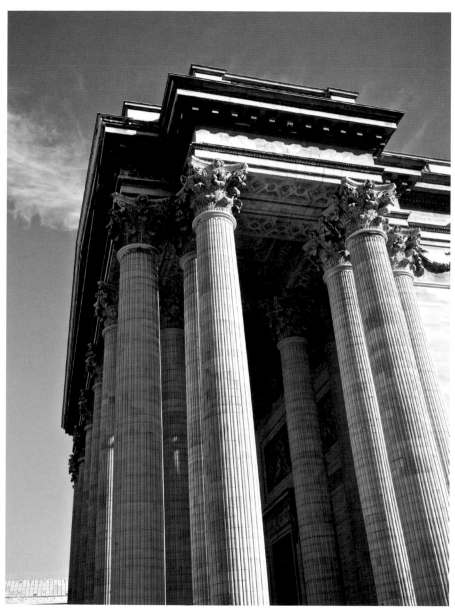

South side of Panthéon

One of the many secrets revealed at night is that the Cathédrale Notre Dame, the center of all the city, has a succinctly different look and feel. It has a spiritual power that shadows the city and turns a landmark during the day, into a luminary vision at night. Hemingway would walk in the late evenings from his Right Bank encounters to his Left Bank apartment, returning home to his adoring, waiting, and faithful wife, Hadley. Together, they would talk of his work, listen to her play the piano, and read in bed at night . . . she being as much the center of his existence at that time as the Notre-Dame is to Paris.

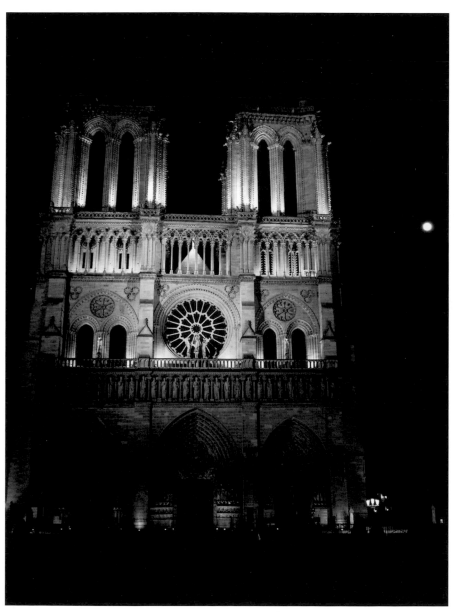

Cathédrale Notre Dame

In his novel, *A Moveable Feast*, Hemingway mentions Les Deux Magots on Boulevard Saint-Germain. Throughout his time in Paris, Hemingway used different cafés for different reasons. Some were used for romance, some for working, and some for business or commerce. When he stopped to work at Deux Magots, he would look across the Rue Bonaparte and see the historic Abby of Saint-Germain-des-Prés, the oldest church in the city. He would order an *apérritif*, open his journal, and begin to write. Hemingway believed that Paris was a city tempted by greatness.

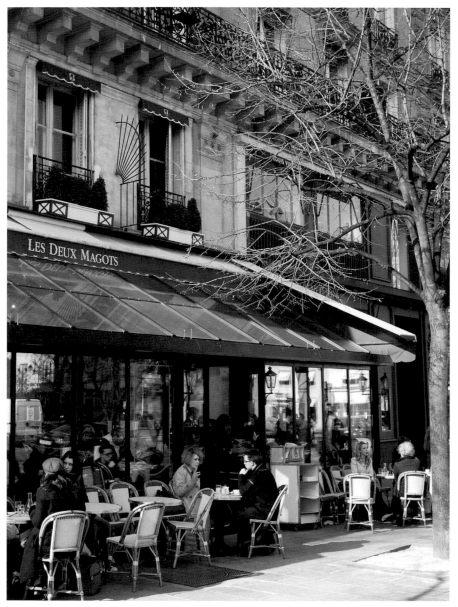

Les Deux Magots on Boulevard Saint-Germain

Hemingway felt he was part of something greater than his own endeavors in Paris. Other artists were collaborating and learning from one another. They grounded and supported the Modernist movement and provided Hemingway with the affirmation and inspiration he needed in order to concentrate. Hemingway, still untainted by fame and fortune, may have subconsciously used these exquisitely sculpted angels found throughout the city. A city that, in the 1920s, was known for being hospitable to strangers, lest they be angels in disguise. These angels serve as muses for the creative, a function that far exceeds their aesthetic purpose.

Façade along Avenue l'Observatoire

Here in the morning, at the Saint Sulpice, Hemingway would find himself and be surrounded by its magnificence. In this sacred and quiet space, his thoughts would be heard aloud—all the way up high to the buttresses. Thoughts about his place within his literary circle, whether he was growing as a writer or providing as a good husband . . . these are the private confessions that would echo throughout the church. What Hemingway did know, was that work could cure almost anything. His religion was his art. With that in mind, he would head out of this handsome and holy place to begin his day's writing.

Église Saint Sulpice

Along the Seine, Hemingway would find solace in the iron moorings anchored to the oldest of walls—the walls in a city that serve any boat or any body in all inclement weather. While in Paris as a budding Modernist, some of Hemingway's personal moorings were Sylvia Beach, Ezra Pound, and Gertrude Stein—all close friends, advisors, and inspirational fellow writers. Hemingway surrounded himself with those he trusted and admired. Those that comprised and anchored the creative storm of a lost generation.

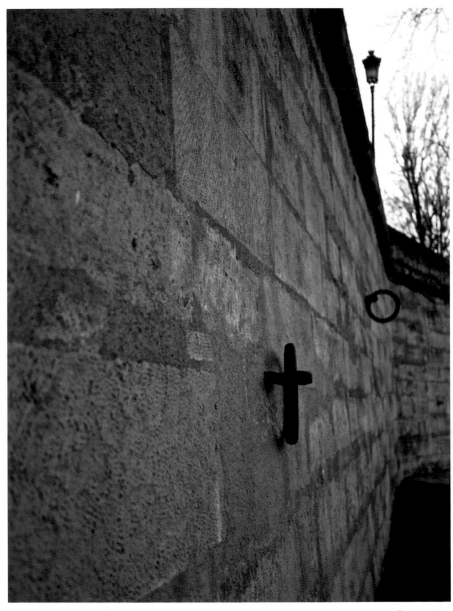

Quai moorings

As Hemingway walked from one Bank to another over the many bridges that span the river Seine, their significance in his life began to translate into his work. Observing the flow of life from any one of these bridges, he could clearly see and feel the beauty and stability of these structures. Hemingway used bridges throughout his writing, both literally and figuratively. They signified events and transformed characters in his work, and stood for transitions and loss as metaphors in his personal life. He would cross and eventually burn many bridges in his lifetime. One, in particular, he would come to regret most of all.

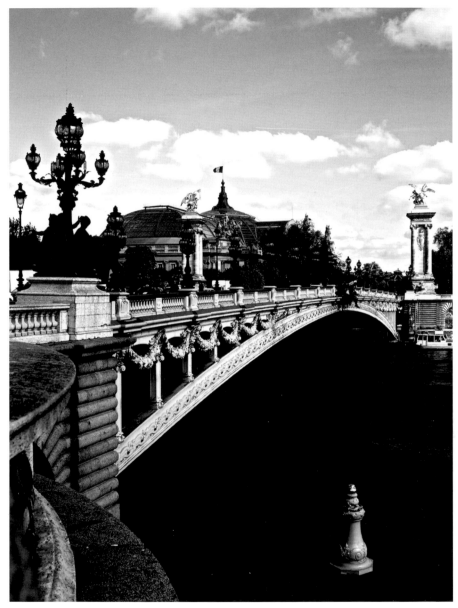

Pont Alexander III

The swiftly moving Seine centers Paris, and helped center a young Hemingway while in Paris. The water flows and changes with the seasons, filling the creative soul with calm and inspiration. Boats travel it during the day, lovers sit by it at night, and no one leaves the city not being touched by it. Hemingway loved the life that existed along the river. The fishermen, the booksellers, and the boatsmen were all part of his life there. He admired the people along the Seine who did what they did well, and did so without reservation.

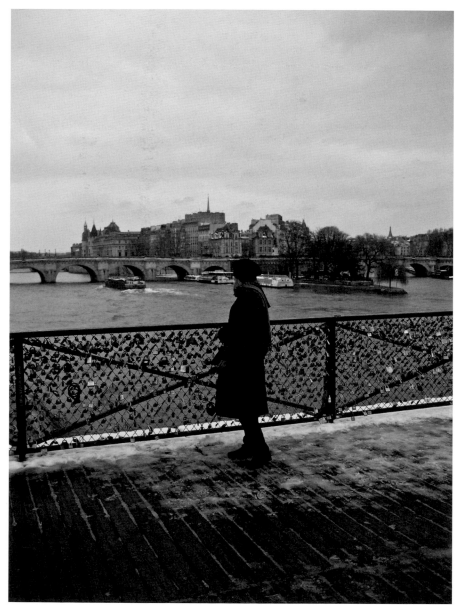

Pont des Arts

Late at night, with the streets emptied and calmed, the glow from the cafés fill the city. Though most were in for the evening, the hope remained that someone would wander in for a nightcap or espresso in such a clean and well-lighted place. In the early years, Hemingway, after a long day's work, would take his Hadley to hidden places such as this to discuss ideas he had for weekend excursions outside of Paris. She was a supportive wife, excited to be in this new city, and far away from her predictable St. Louis life, with a man whom she loved and admired. A man she believed would one day rise above all other writers of the Twentieth Century.

Café near Boulevard Saint-Germain

Inspiration. Hemingway believed that it could be found everywhere in the city of Paris. From the powerful river, up to the graceful bridges, past the stunning architecture, and to the divine sky, there is a serenity here. Paris holds intrigue, and a powerful draw that invites people to return over and over again. Hemingway, with his wife Hadley alongside, embraced this city and all that it afforded him in the early half of the 1920s. He instinctively knew that all people, no matter how little they had, if in Paris, they possessed great treasure . . . Paris itself.

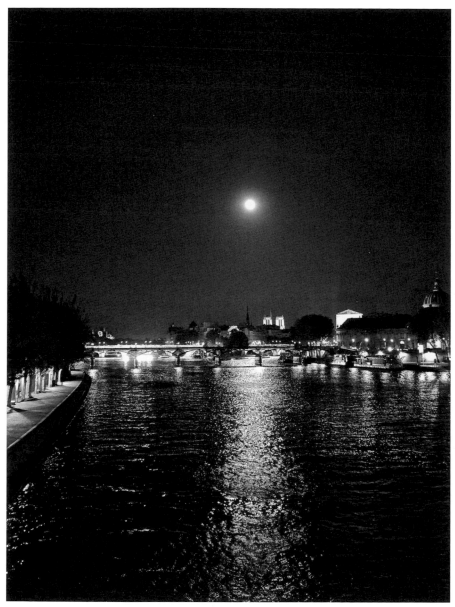

Looking east from Pont du Carrousel

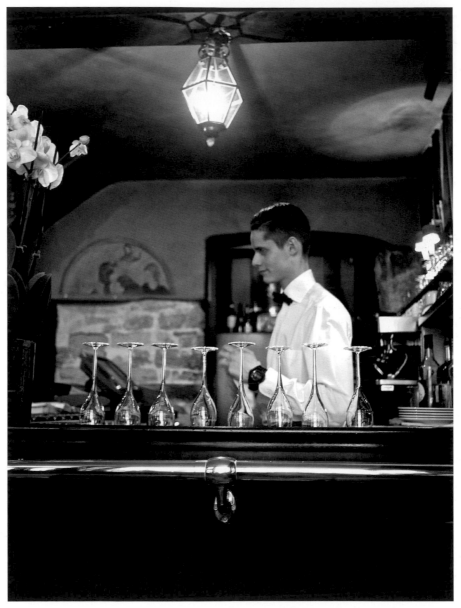

La Petite Chaise

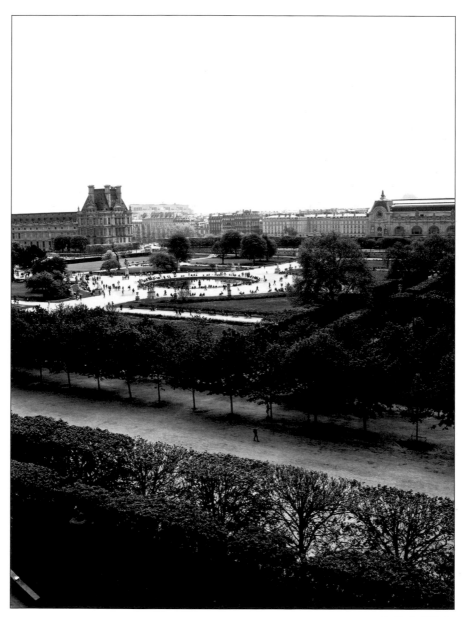

Jardin des Tuileries

II

Craft

A young Ernest Hemingway, in the early 1920s, honed his skill as a master of prose through his intention to create suggestive, highly personal, and intensely emotional writing through his disciplined work ethic. He found inspiration in cafés, along the banks of the Seine, on long walks, and living among the greatest modernists of the Twentieth Century. Hemingway filled his creative spirit by being a part of a city that afforded him a life and a community in which he was able to begin to perfect his craft and wrote what most scholars believe to be his finest and most considered work. There is no disputing the fact that Ernest Hemingway was an innovator of Twentieth Century prose, and that it all began to take shape in the early years of his Parisian experience.

The steep eight-spiraled flights of stairs lead-
ing up to the rented room where Hemingway
wrote, in the tired Hotel Midi, were worn
and rich with age. In the morning, he would
make this climb while contemplating the
story he was about to create–one that would
express a deeper truth. It is clear from the
unbalanced nature of the stairs and the height
to which they reached that only a youthful
man, without much money, would make this
kind of climb to work each day. Hemingway
once reported that during this time in his life,
when he returned to this room from climb-
ing in the Austrian Alps, Paris seemed small
and distances shorter. When his work was
done, that time when the writing was going
along well and he had a deep understanding
of what he would write the following day,
Hemingway would walk down this long flight
of stairs into a city he loved, a city that would
refill his well.

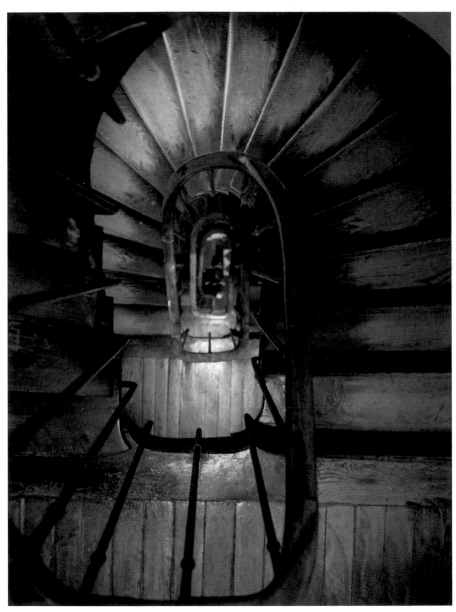

Stairs to Hemingway's rented room

This is the view Ernest Hemingway would see as he spent his days working in his eighth floor room at 39 rue Descartes. It was the Panthéon that Ernest had omitted when, in *A Moveable Feast*, he told the story of standing in his rented room and looking out over the rooftops of Paris. It was the view of the Panthéon–the very place where the souls of French literature rest–that consequently inspired Hemingway to dismiss all ornament from his writing and to write the truest sentence he knew. In this cramped space high above the Left Bank, Hemingway learned to focus and describe the telling details of the scenes he would compose through his prose, those details which conveyed the purest emotion. This took an intense concentration, and this was the view that helped drive him to create and express a deeper truth.

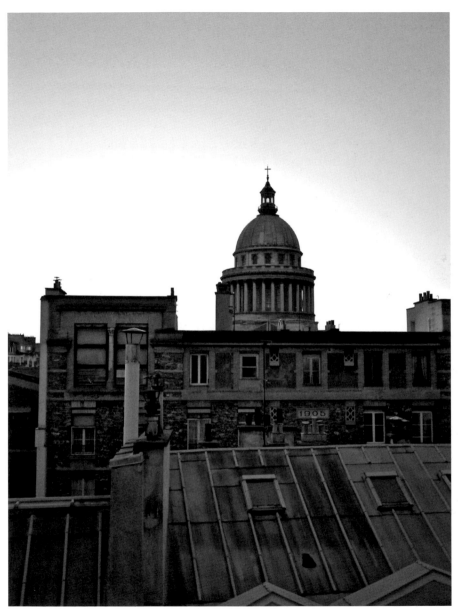

Rooftops and Panthéon looking west from Hemingway's room

Omission. This is considered one of Hemingway's greatest gifts to literature. While in Paris in those early years, he wrote many short stories as well as his book, *The Sun Also Rises,* a novel that stirred the literary community and became his first major success. His unique prose developed and matured, becoming more suggestive, and he theorized that one can omit anything one knows and the story will be strengthened and felt, profoundly, by the reader. Not unlike Hemingway's writing, these moorings found along the Seine are surprisingly strong yet simple, and one can feel the depth of the stories they quietly suggest.

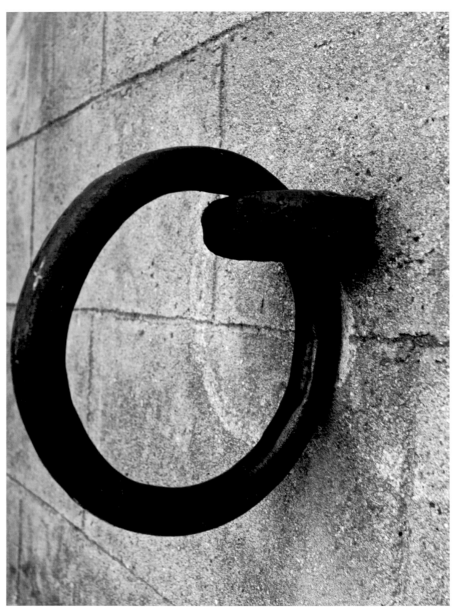

Mooring along the Seine

Hemingway felt at times he needed to be around other people in order to be alone. In his rented workspace on the rue Descartes, he learned how to concentrate fully and this allowed him to work anywhere. The lively cafés of Paris afforded him a less expensive place to work, and when he was in one, he could write, drink café crèmes and, being somewhat superstitious, hope for luck. Even today, one can easily spot a writer hunched over paper or laptop in one of the many cafés throughout this city. This unspoken invitation comes from Hemingway himself.

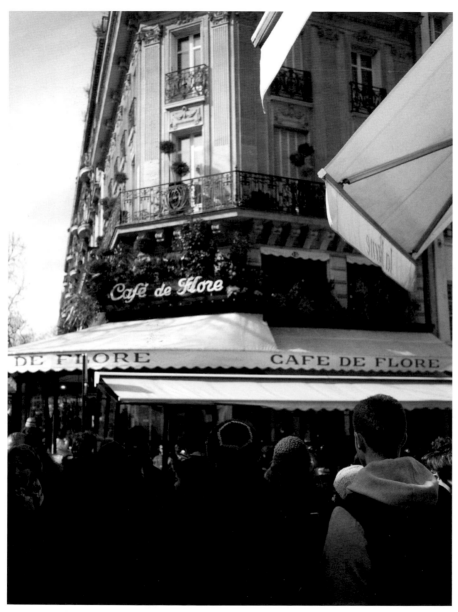

Café de Flore on Boulevard Saint-Germain

Three years before Ernest Hemingway arrived in Paris, the French sculptor Auguste Rodin died. It seems that there are always new and inspired artists to fill the shoes of those that walked the city of Paris before them . . . one great artist passes and another is there to discover what has yet to be shown. While walking through the grand museums or wandering the city, Hemingway would find that his search for new and meaningful experiences far outweighed his quest for knowledge. Many people merely touched the glass over the picture of Paris, while Hemingway lived deeply within it.

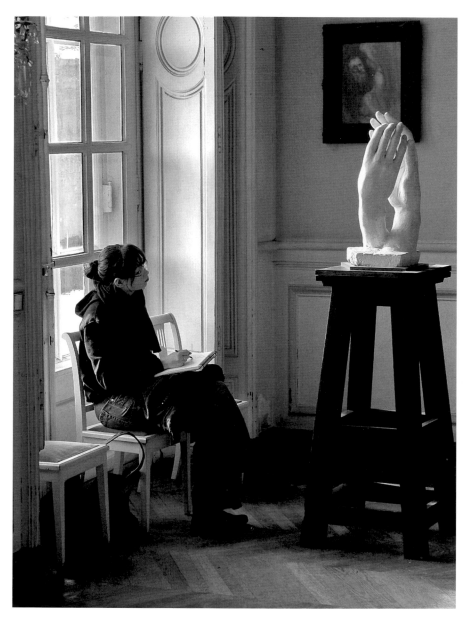

Woman in the Musée Rodin

Discipline and observation are the hall-marks of genuine artists–any who practice their craft with deep intention. Art, in and of itself, is the state of constant decision making. Hemingway admired people that took their profession seriously, those that approached their craft through interested eyes. Hemingway never compromised his work ethic, and through his writing, he kept his focus on the human spirit and not simply on appearances, trying always to reach the essence of his subject. He was a man that lived hard and worked hard, and surrounded himself with those that did the same.

Café de Flore

What was Hemingway connected to in Paris? To learning? To language? To simplicity and clarity? To living life? To simple food and fine wine? To the art and to the events, and to his acquaintances and colleagues that filled the streets and cafés and his time there? Hemingway knew well that writing requires a full soul, an abundance of experiences, and those periods of quiet and solitary reflection in which to recreate them on paper.

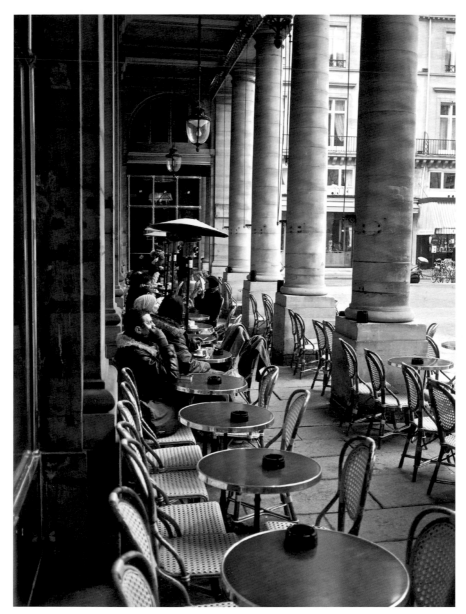

Le Nemours near Le Palais Royal

Walking within the gardens, Hemingway was synonymous with his surroundings, trying to capture the images before him clearly and simply. Cézanne, Pissarro, Van Gogh, Manet, Gauguin–they were all in him as he painted his prose. He created his own landscapes impressionistically, trying not to reproduce nature, but to represent it through careful construction. Hemingway thought visually as he wrote and would, at times, break free from short declaritive sentence structures by setting images, all connected by *and*s, in motion–thereby presenting human experience in a new and alluring way. The goal of his writing was to invite his readers in, to surround them with his story, and to make them a part of his experience.

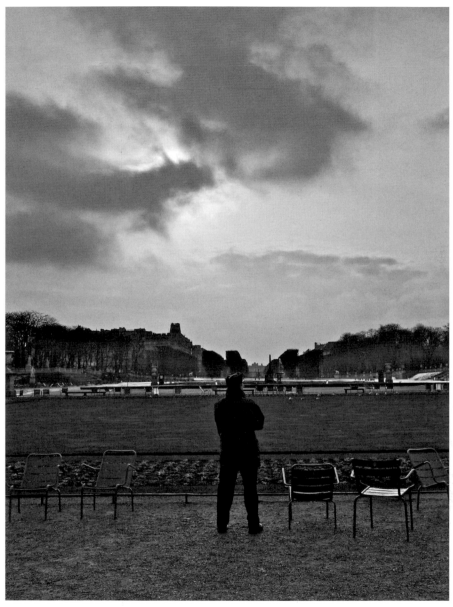

Jardin du Luxembourg

While writing in the Closerie Lilas one day, Hemingway looked up from his work to see a woman sitting alone. In his mind, he believed he had seen beauty, and that it belonged to him now—that she belonged to him and that all of Paris belonged to him. Then, looking down to his notebook, he was back in the wilderness of upper-Michigan with his alter ego, Nick, in "Big Two-Hearted River." Hemingway knew very well during this period of time that, above all else, he belonged to his pencil and to his notebook.

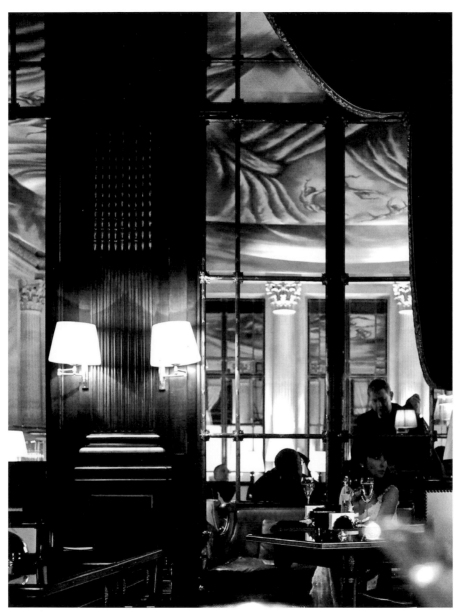

Bar 228 in Le Meurice

Hemingway has said that by studying nature, and by studying those whose art was filled with nature's beauty, his writing was strengthened. Through viewing the work of Cézanne and others, he learned how light was reflected through trees or upon buildings, or the way it fell upon a face. Hemingway set out to achieve this through his suggestive and innovative style. His sentence structures were like the rapid, bold strokes of a painter's brush, and, by limiting his words, he could portray the same sense of clarity and importance that Cézanne's work held. Capturing the purity of nature helped form the writing and the literary imagery for which he is known.

Quai Voltaire

The players in 1920's Paris could be spotted, quite by intention, at the Rotonde. This was the café in the city from which to be seen. Hemingway, though, preferred only to look in and not stop. He chose to be an outsider, to move past the Rotonde quickly, often varying his routes to avoid falling into lazy habits. He liked the anonymity and honesty less public cafés afforded him, for in those places he could be himself and lose himself in his stories—stories that were written by a man yet untouched and yet unburdened by fame.

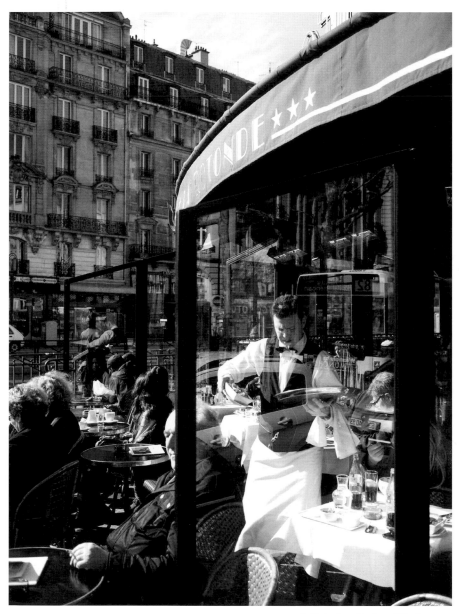

La Rotonde on Boulevard Montparnasse

As Hemingway would walk from the Left Bank over the Pont de la Tournelle, he could circumnavigate the Île Saint-Louis by way of the scenic Quais: heading east, the Quais' de Béthune, d'Anjou, de Bourbon, and d'Orleans. This walk captures what was strikingly real and pure in Hemingway's Paris of the 1920s. Many of his favorite walks around Paris are found within the pages of *A Moveable Feast* and *The Sun Also Rises.* After all, there was a travel writer within Hemingway that simply wished to share the places he loved most.

Île Saint-Louis

This was and remains to this day, the home to the literary crowd in Paris, the devote book-lovers who stop and spend time at Shakespeare and Company. With talk of teaching and travel–London, India, South Africa and beyond–someone once said, "There is nothing, just truth. And books." Another said, "Just give me a book, any book, for twenty hours." Hemingway made Sylvia Beach's sanctuary his home away from home. He loved the honest appreciation of literature and the support he received in this small but important Left Bank bookshop on rue de l'Odéon. Shakespeare and Company was, in part, what made Paris exceptional for Hemingway.

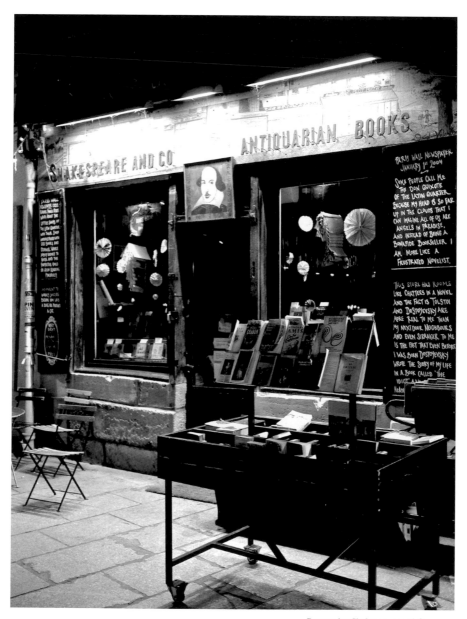

Present day Shakespeare and Company

Surrounded by the art and culture of this great city, Hemingway's spirit and soul were transformed. While far from the United States, he discovered his ability to write about the wilderness of his childhood and was able to capture the simplicity of his own personal, and very American, landscape. Hemingway learned to believe that stories only become whole when the writer's words—the people and places, and their remorse and sorrow—are allowed to collide with the reader's own experiences and interpretation.

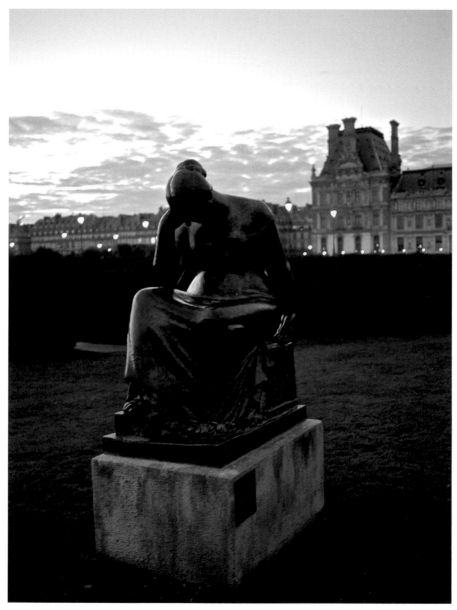

Jardin des Tuileries

Hemingway instinctively knew that the best of life is found in sparse, small details. His profoundly considered yet simple descriptions make the pages of his work come alive. He believed writing was not served well by embellishment, or through the use of adjectives and adverbs. With Hemingway, it was the wine, a Côte de Brouilly. The bread, and the dish baked in an oven hot with six escargots. The deep drink of red before each bite. And the candles and dim lamps that lit him were just enough to illuminate everything he needed or wanted.

La Testevin on Île Saint Louis

Book Talk. Monday, March 8th, 1923: The intimate crowd that gathered for the evening readings asked, "What about craft?" "What was the process like?" "What did you discover about writing?" "What about language?" "Is it about the city, or is it about the narrator?" You want all those that end up in a place like Shakespeare and Company to ask these questions. Hemingway knew the answers—he knew them because he immersed himself in the intricacies of his work. He believed in his art, trying to make the English language new by changing the rhythms of writing and by creating a minimalist approach to prose that would affect and impact generations to come.

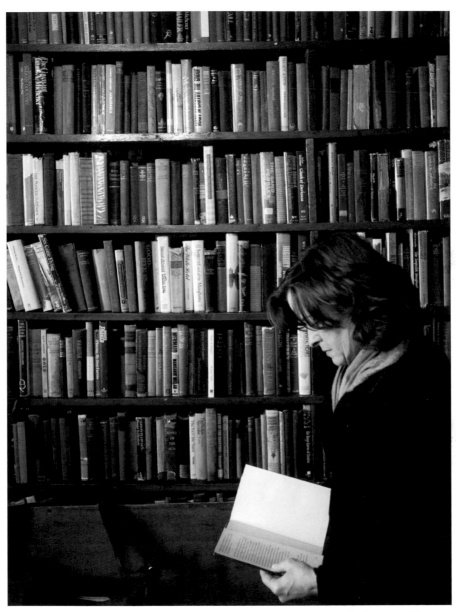

Second floor of Shakespeare and Company

Forty years later, while trying desperately to find the right words to complete *A Moveable Feast* in Ketchum, Idaho, a broken Hemingway used his ability to emotionally transplant himself to one of his cherished cafés on the Left Bank. By doing so, it brought him closer to his time in Paris, the time when he and Hadley were in love and when his writing was new and untarnished by years of complexity. By being as close to his time in Paris and in his youth as he could be, Hemingway put himself at great risk. In the end, this risk proved to be too much for him.

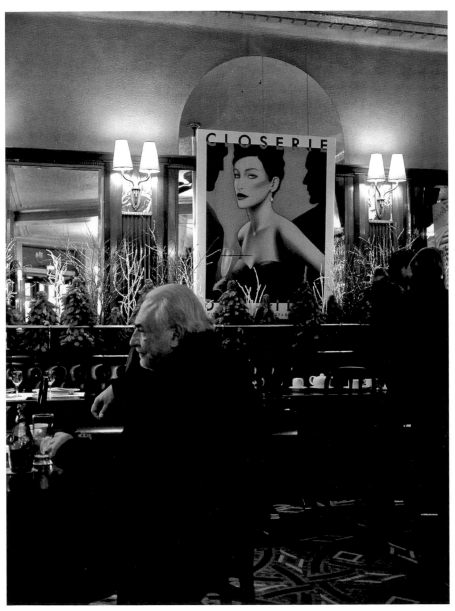

La Closerie des Lilas

Craft. Repetition. Brevity. Voice. Clarity. All aspects of his art for which Ernest Hemingway is known and revered. As Hemingway looked north in the evening from his rented room at the Hotel Midi toward the illuminated Sacré-Cœur, he could watch the sun set upon this city from the place he worked. Life evaporates and people make choices. Like Hemingway, some choose to create. It is what they do. To make things that will stand another day. Since the days his eyes fell over the Parisian landscape, many writers have said it is impossible not to work in Hemingway's shadow.

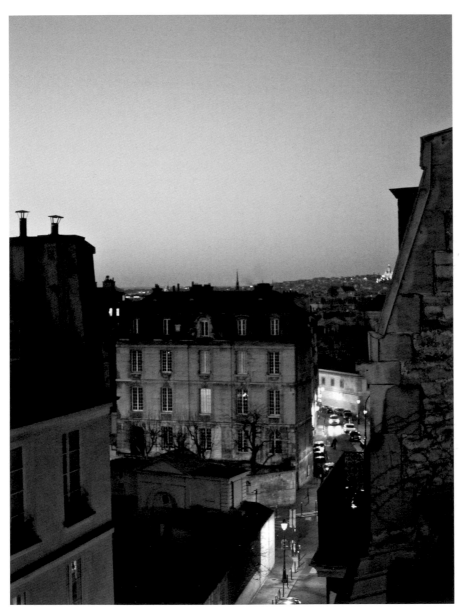

North view from Hemingway's room

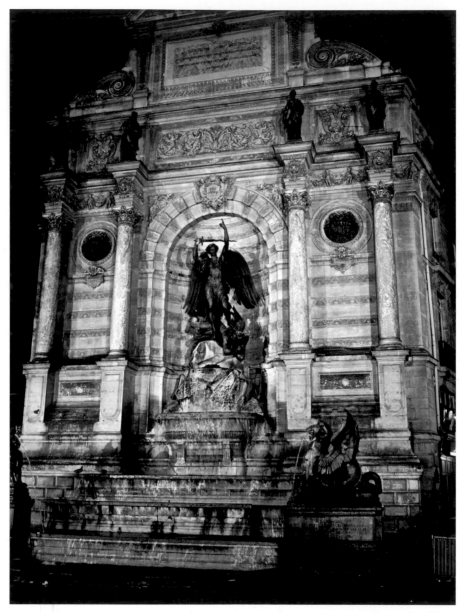

Fontaine Saint-Michel

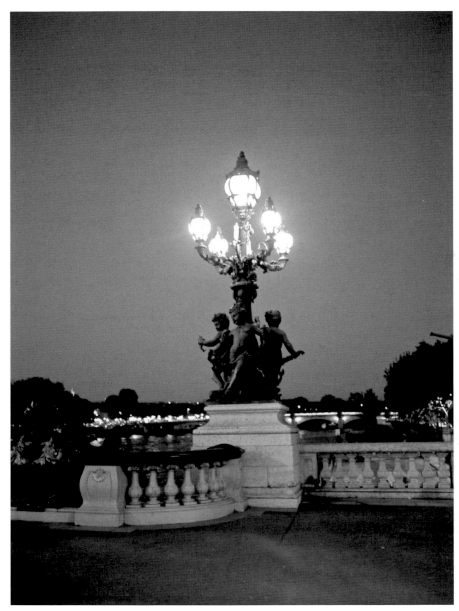

Pont Alexandre III

III

Influence

Ernest Hemingway was surrounded with colleagues and good friends during his time in Paris. He was a part of the movement that was influencing and redefining art of all types. Together, they started small literary magazines, looked for benefactors, and supported one another. In post-World War I Europe, the artists who flocked to Paris shared a simple purpose: to create new work in all genres that would serve to break the constraints of previous form, tradition, and content. Together, they planted their vision firmly and securely into the foundation that would light the Modernist Movement. Later in his life, and throughout his memoir, Hemingway would look back on those Paris years of the 1920s, and reflect upon the many influences that contributed to his rich experience there.

Hemingway believed that seven-eighths of a story should remain hidden beneath the surface. He referred to this as the Iceberg Theory. The emotional strength of any story should be felt and not necessarily seen. The Closerie Lilas, the café where Hemingway sometimes worked, was by location and appearance the tip of the iceberg that comprised the Left Bank of Paris. From a higher perspective, one can see the Boulevard Montparnasse reaching down to the Rue de Vaugirard, over to the Boulevard Saint-Michel, and eventually returning to the tip of the iceberg–the Lilas. This theory is much more than just metaphor. It is a symbol of the Paris Hemingway occupied, and it is symbolic of those artists who encompassed the Modernist spirit and that worked and lived on the Left Bank. All who influenced Hemingway are considered to be the foundation of his literary iceberg.

Closerie des Lilas with Sacré-Cœur in background

The eclectic and dark parlor at 27 rue de Fleurus belonging to Gertrude Stein was legendary for its introductions of artists and conversations on art. Walls were lined from floor to ceiling with paintings–paintings created by contemporaries such as Pablo Picasso and Henri Matisse. By many accounts, it was one of the warmest, most comfortable and finest rooms in all of Paris. Stein was a generous host, giving of her time and of her expertise. She took Hemingway under her wing after an introduction by Sherwood Anderson, and they quickly became close friends and confidants. Stein saw in young Ernest a blank canvas upon which to impress her influence. In her, Hemingway discovered an honest and influential friend, as well as a future godmother to his son, Bumby.

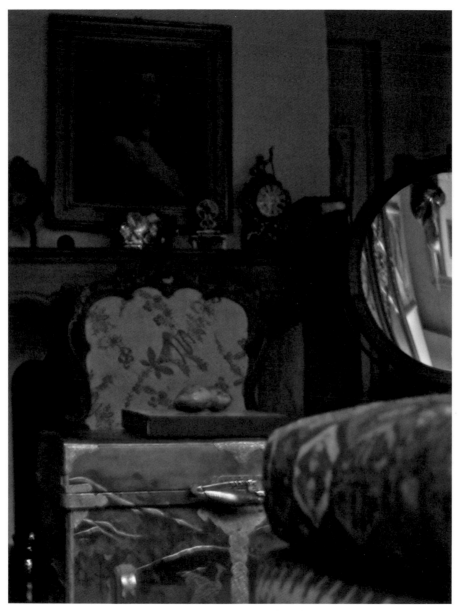

Gertrude and Alice's parlor at 27 rue de Fleurus

Down the narrow and wind-swept rue des Champs that runs parallel to the busy Boulevard Montparnasse, was the home of Ezra Pound–Hemingway's neighbor and mentor in Paris. Pound promoted artists he believed in and encouraged them to stand on his shoulders. His aim was to push the modernist spirit to new heights and to nurture and to sharpen the skills of valued colleagues he knew would help accomplish this. Among the many lessons Pound would impart, and perhaps the one that Hemingway learned best, was the necessity of revealing the essence of a sentence through constant revision and meticulous elimination.

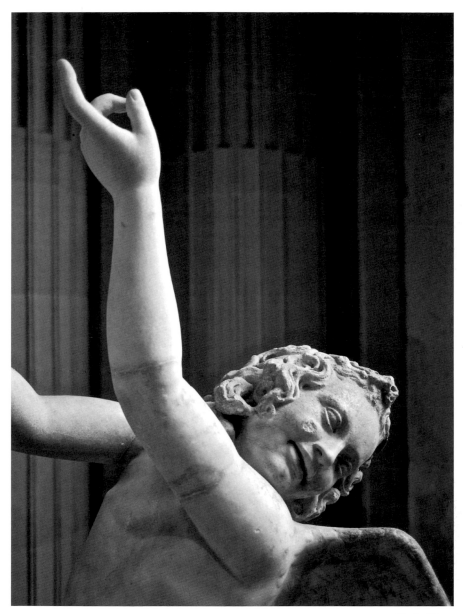

Musée d'Orsay

Some believe Stein and Pound to be Hemingway's literary Mother and Father. Together, they saw in Hemingway enormous promise, and under watchful eyes they helped him develop a literary network and platform from which he could be recognized. Both Stein and Pound provided him the necessary advice and acceptance he needed to become one of the brightest young stars in their community. Their ties to Hemingway were braided with intimacy and instruction, and, like most parental relationships, they instilled in him the confidence he needed to flourish.

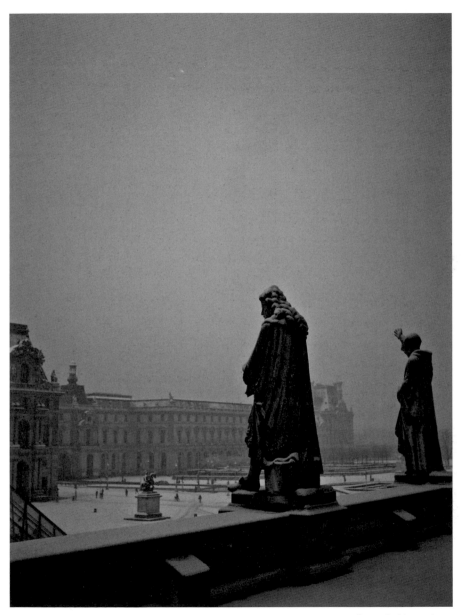

Louvre looking southwest

Sylvia Beach opened Shakespeare and Company, her American bookshop, in 1919. She was the Patron Saint of the Modernist Movement, creating a spirit in her shop of sharing and collaboration. All those that entered her doors, including Ernest Hemingway in 1921, were warmly greeted and welcomed. Shakespeare and Company became a safe haven from which to share ideas, read poetry and introduce unpublished manuscripts. Sylvia Beach singlehandedly undertook the daunting task of publishing James Joyce's *Ulysses*, the literary masterpiece that would inspire and define The Lost Generation. In Shakespeare and Company, Beach created an environment which allowed her friends to pursue their artistic destinies.

Second Floor, Shakespeare and Company

East of the center of Paris stands the Gare de Lyon train station–an expansive, towering place that stays cold beyond winter. Looking up at the clock on the far right hand side of this historic terminal, time seems unaltered since the Hemingways, a newlywed couple from America, first arrived. It was here that Sylvia Beach waited for the train to bring the first copies of Joyce's *Ulysses* from the printer in Dijon. It was from here Hadley unintentionally lost her husband's suitcase–which contained originals and copies of his first set of short stories and a novel. Great writing moves along the tracks of the mind . . . and the Lyon represents perhaps the most influential aspect of Hemingway's experience, which is his love of travel and his need for constant motion.

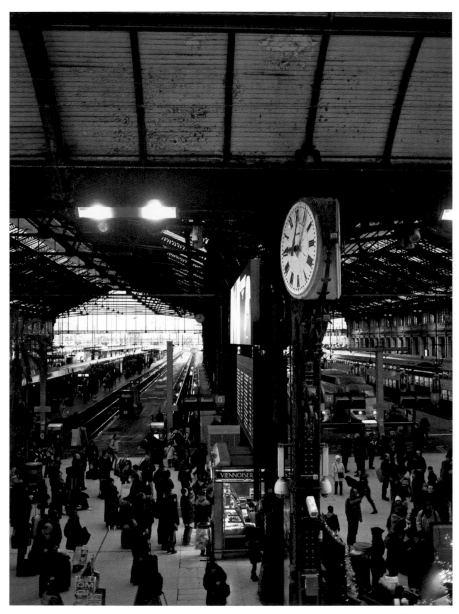

Gare de Lyon

Hemingway considered his colleague and friend, James Joyce, the greatest fiction writer in the world. In *Ulysses*, which Hemingway eventually helped distribute in America, the Modernists discovered a threshold upon which to explore moods, develop feelings, and investigate thoughts by creating characters in more significant and profound ways–stream of consciousness writing and an emphasis on mythology influenced many during this time. *Ulysses* became the apotheosis of Left Bank artistic liberation. Early on, Hemingway had seen Joyce's brilliance in his bouquet of short pieces titled *Dubliners*. Hemingway felt the coherence in these stories–how they were carefully arranged through recurring themes, characters, and settings.

Hôtel George V

Literary unrest simmered under the surface during the time Hemingway spent in Paris. Ford Maddox Ford, a soldier, self-promoter, and controversial writer, influenced Ernest Hemingway's own sense and understanding as to the significance of publicity. Controversy, and having one's name out in the public arena, mattered. Yet Ford, the author of one of the most beautifully written novels, *The Good Soldier*, was an enthusiastic man and one dedicated to the written word. Hemingway shared Ford's commitment. Each writer had a profound belief that what they were doing was the only pursuit worthy of a serious man. They believed and invested everything in the beauty of an image that was evoked simply by placing one word beside the other.

Musée de L'Arm

Dear Max:

This is to tell you about a new writer living in Paris. Look him up right away. His name is Ernest Hemmingway [sic] and he is the real thing.

This is what F. Scott Fitzgerald, an expatriate living in the south of France, enthusiastically wrote to his editor, Maxwell Perkins, at Charles Scribner's Sons. Fitzgerald made his recommendation after having read Hemingway's small collection of literary sketches titled *in our time*, published by Bill Bird's Three Mountains Press on the Île Saint Louis. Sent in 1924, this note marked the beginning of what would become one of Hemingway's longest lasting and most influential relationships . . . the one that existed with Maxwell Perkins, the finest editor of the age.

Hemingway Bar in the Hôtel Ritz

The Dial, the *transition* and *the transatlantic review* reflect a period of time when art overcame ego and collaboration took precedence over self-promotion. These journals, with their worn edges and ideals, would serve as relics and reminders of when writers worked together toward the greater good of their profession. They stood in opposition to the belief that artists are bad risks for both friendships and relationships, that they save the greatest parts of themselves for their own work. Hemingway recognized, eventually, that independence in fact did outweigh association. Literary ambition in 1920's Paris turned into literary competition.

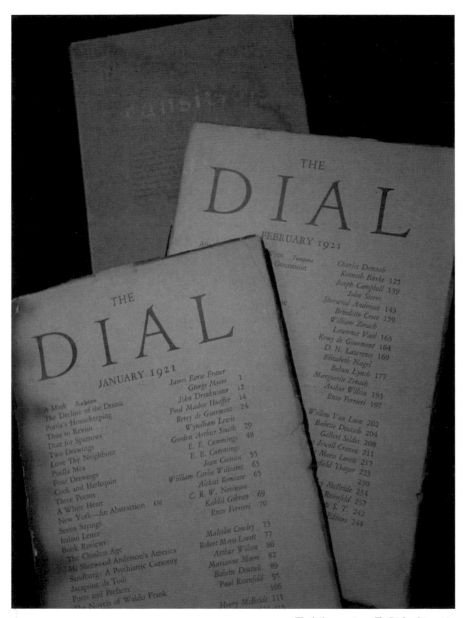

The little magazines, *The Dial* and *transition*

Women held a strong position in Hemingway's life and in his work. He had the support of a loving wife, he had Stein and Beach promoting him, and he was part of a community that included Edith Wharton, Anäis Nin, Hilda Doolittle, and Lady Duff Twysden. Their collective energy and intelligence nurtured the development of the movement on the Left Bank, and they helped establish a new and exciting prototype of the modern female. To Hemingway these women represented a new model, one of empowerment and equality, and one that was shattering stereotypical norms. These were women he admired and who possessed attributes Hemingway would later use to create powerful and entrancing female characters in his work.

South end of Jardin du Luxembourg

Marcel Proust, the unspoken godfather of the Modernist Movement, wrote in silence in his room—a room he had lined with cork in order to seal himself off from distraction, sickness and sound. A dying man, he made a vow to live long enough to complete his masterpiece, *In Search of Lost Time*. Proust's influence of unyielding discipline and complete willingness to sacrifice, served the Modernists as a symbol of what true dedication meant in their own personal pursuits. Proust knew he would not live to see his art's impact, nor would he ever know of the monumental influence he would have on Hemingway and on this new generation of writers.

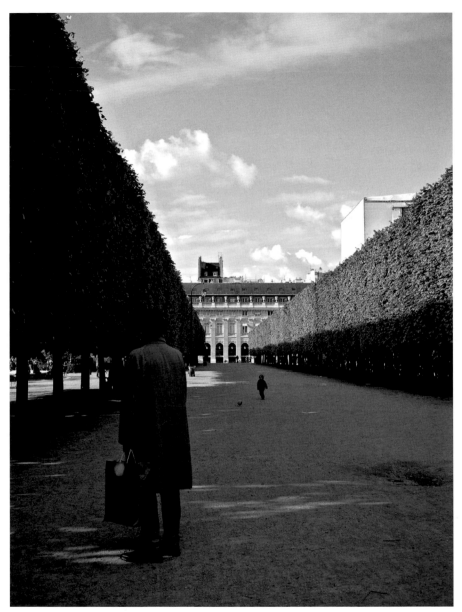

Le Palais Royal

After his apprenticeship at *The Kansas City Star* in his late teens, Hemingway worked as a foreign correspondent based in Paris, sending dispatches from a torn, post-war Europe back to the *Toronto Star*. Through journalism, Hemingway was able to hone his craft, concentrating specifically on his less-as-more philosophy. Journalism allowed Hemingway to visit other parts of Europe, and many of these experiences would eventually become backdrops for his stories and in his novels. Not only did journalism ground Hemingway in those early years, but it also reinforced the lessons learned from Stein and Pound, forging one of the most influential narrative styles of the century.

Église Saint-Sulpice

111

Perhaps one of the most heavily felt influences on the artists of the early Twentieth Century was World War I and its aftermath. Casting its long shadow, the war needed to be psychologically and artistically processed before moving forward—there needed to be a sensitive register of what a tragedy the war truly was. Experimentation with techniques to convey the disorientation left by the war led to a more graphic style of prose. Writers were beginning to convey their characters' internal moods and thoughts in original ways through dynamic wordplay. The weight felt as a result of the Great War left Hemingway and all those around him with the dubious challenge of reinventing their art.

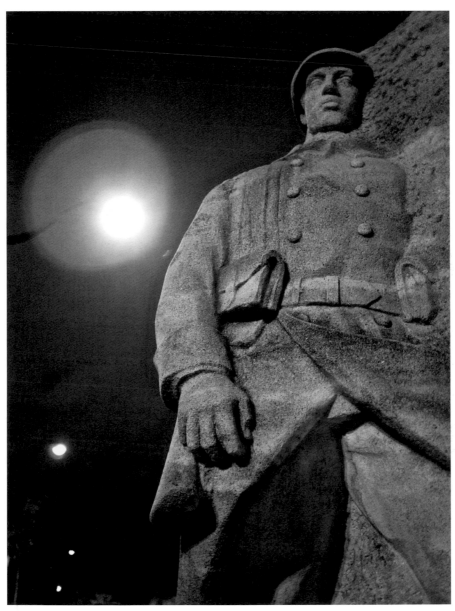

Base of statue Marie Émile Fayolle

So much of who Ernest Hemingway was in those early years in Paris can be felt along the river's edge. At times, he believed he was in over his head, specifically regarding his lack of a formal education. He was constantly looking for the connection that existed between ideological discourse and concrete reality. Hemingway, however, had a fighter's heart and work ethic, and found he was able to play to his strengths in spite of being surrounded by older, Ivy League-educated and more experienced contemporaries. It is the depth of Hemingway's submersion in Paris that taught him many lessons he would carry throughout his life.

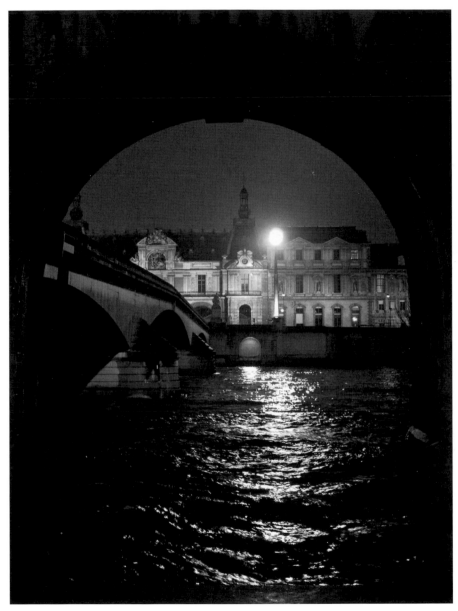

Pont du Carrousel

The demands of art often require a release. Whether drinking alone, with Hadley, or in the company of friends, for Hemingway, Paris was indeed a *Fête*... a *party* to be experienced fully. From fruit aperitifs in Stein's parlor, to fine bottles of red wine at Prunier's, to the simplicity of a warm rum at Café Dome, the effects of alcohol enhanced the social experience. Throughout *A Moveable Feast*, and in many stories and novels, Hemingway references the unquestionable influence of alcohol during his years in Paris. Whether in work or play, Hemingway believed in giving it his all.

Bar inside La Closerie des Lilas

After years of dedicated work and influential guidance from those around him, Ernest Hemingway developed a style that would eventually lead him to worldwide recognition. His time in Paris reading the works of the Masters, and viewing the great paintings in the many art galleries, provided for him the lessons that helped give him the confidence necessary to experiment with and produce highly original prose. Hemingway came to believe that creation was a matter of life and death, and his future work would reflect this lesson. At the conclusion of his years in Paris, Hemingway had mastered a new form of writing governed by Left Bank rules, and he had absorbed what amounted to an extraordinary education.

Paris-Sorbonne

Influence. Hemingway, in a famous *Paris Review* interview, remarked that he wrote best when he was in love. Critics and scholars over the years have concluded that Hemingway's strongest writing was created before 1928. If true, perhaps Hadley was his greatest influence, and representative of the best of his literary career while in Paris. While playing her part during those formative years of his writing, Hadley was the story itself . . . she was the beginning, middle, and in *Feast*, the end.

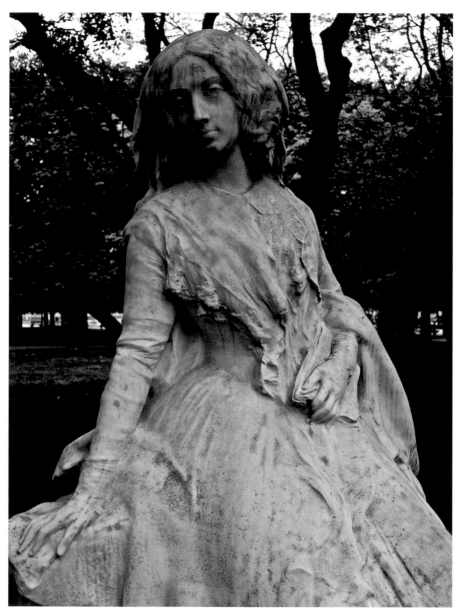

Jardin du Luxembourg, George Sand

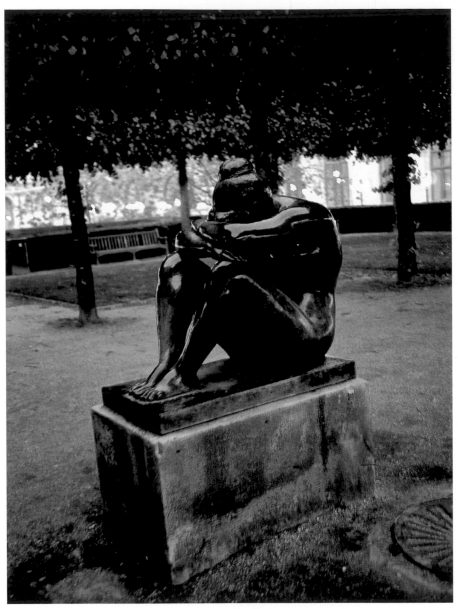

Jardin des Tuileries

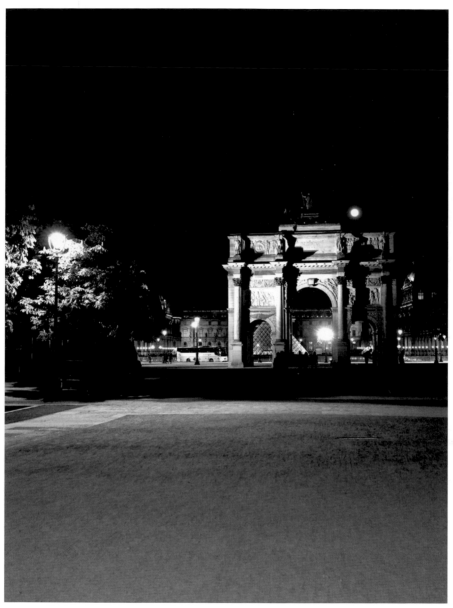

Arc de Triomphe du Carrousel

IV

Love

There is no better city than Paris in which to love. There is no worse city than Paris in which to love and to lose. Hemingway was told by a close friend that the only place for a writer to go was Paris. He moved there with his first wife, Hadley, and together, they would share a love for one another and a love of the city. For six years, they basked in the light of its creative center . . . unaware of the sorrow that lay ahead. Hemingway would eventually leave Paris without Hadley, and without their young son, John. It would be four decades later that Hemingway would return to Paris with his memoir, *A Moveable Feast*–his poignant apology to Hadley for the tremendous pain he caused them. Paris was the city in which the young couple lived and worked, loved and lost. It was there that Ernest Hemingway, in order to write his one true sentence, gave up his one true love.

The doorway in Paris to which all Ernest Hemingway enthusiasts come, hoping to gain entrance. When opened, this door to Ernest and Hadley's first apartment, a two room flat, offers a resting place and a glimpse into the simple life they shared on the fourth floor. Though at the time, theirs was an undesirable neighborhood, far too close to the Place de la Contrescarpe and noisy *bal musette*. In spite of location, this young couple, one a skilled writer and the other his adoring wife, conceived their only child and lived happily for nearly two years behind this door.

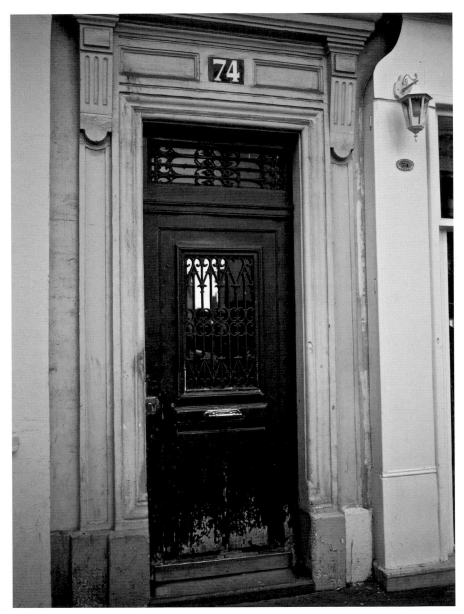

Ernest and Hadley's apartment at 74 rue Cardinal Lemoine

Hadley believed in her marriage, and trusted that Ernest would love no one else but her. She was completely devoted to him, and a feeling of security enveloped her as she offered everything she had—emotionally, physically, and financially—to the encouragement and to the well-being of her husband, the writer. Hadley's world in 1920's Paris was centered on Ernest, and she believed completely that, as a couple, they defined happiness.

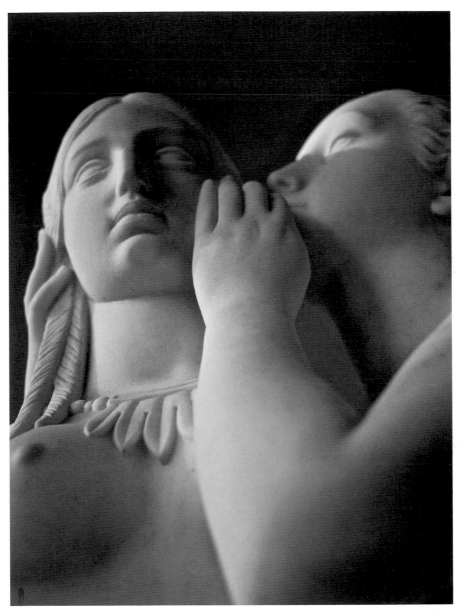

Louvre, *Premier Secret Confié à Vénus*

Ernest and Hadley shared in a city alive with the Modernist spirit. Hadley, when engaged to Ernest shortly after his return from the Italian Front in World War I, said that the world was a jail from which they would together break free. In Paris, they met many fascinating characters and counted on one another for strength and direction. Hemingway marveled at the power of love that was felt in a city where couples are seen everywhere and where romance flourishes. While couples abound on many of the pages of his work, eventually, in his personal life, the concept of a lasting relationship with another seemed to elude him.

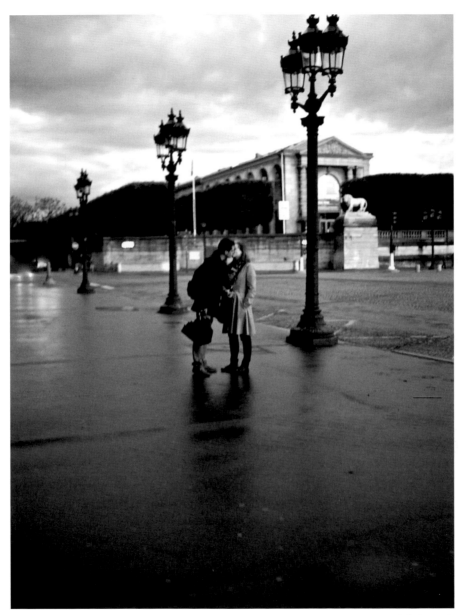

Place de la Concorde

When a newly married Ernest and Hadley first arrived in Paris, the city was theirs–a constant gift to be opened. Weekend trips and intimate excursions outside city limits and to other countries gave them much to discuss and allowed them to rely upon one another. Together, they experienced the freedom of post-World War I Europe–they believed that the world was theirs for the taking. With high aspirations and hearts full of hope, Hadley soon became pregnant, and they felt blessed with the impending arrival of their son, John, whom they called Bumby. The Hemingways could not have been happier or more in love.

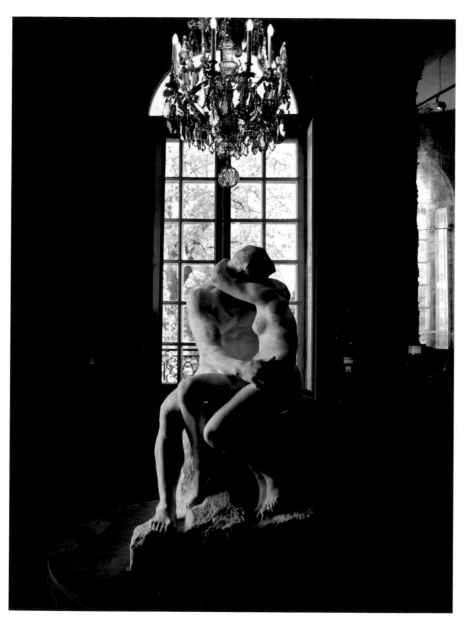

Musée Rodin, *The Kiss*

Alone, Hemingway was a serious and contemplative man. With one other person, he eventually became restless. With two others, as it was so many times in his life, he was intrigued. It seemed as though there was never room between wives and lovers. Eventually, Hemingway strayed from his marriage to Hadley. Shortly after the birth of their son, an affair with another woman began, and revealed itself to her. Though devastated, Hadley handled herself with grace and stoicism, and eventually she moved forward. Hadley knew she needed to let go of Ernest.

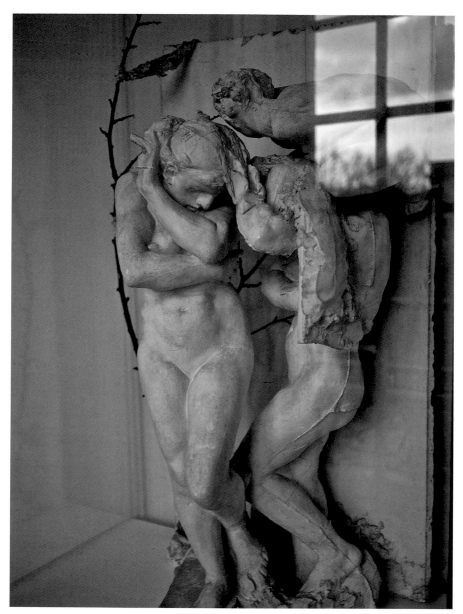

Musée Rodin

Walking alone along the north side of the Île Saint-Louis, Hemingway experienced inner conflict under the weight of both his personal indiscretions and his professional aspirations. There were always unanswered questions that awaited explanation. Sitting alone on this stone bench, surrounded by Paris' scrupoulous attention to detail, something terribly important was missing. Was Hemingway alone or was he, and were they, all one? Both are thoughts contemplated by a man who was highly sensitive and sensory— one speaking to his loneliness and regret, and the other to his uncertainty.

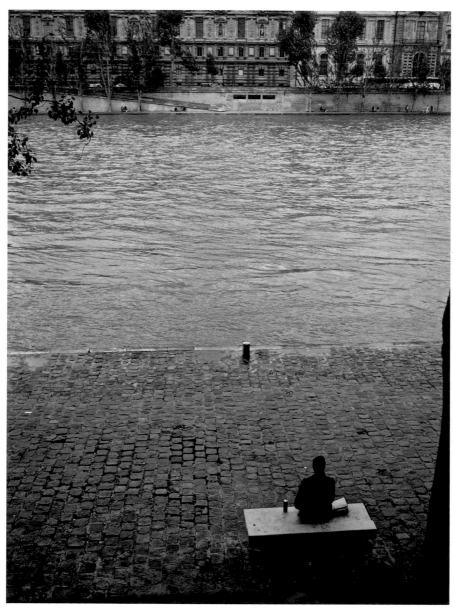

Bench along Seine

In 1926, Ernest and Hadley Hemingway officially separated. For Hadley, the ending of the marriage meant tremendous loss. She was a young mother, and now a forsaken wife with an unsettled future. She was stripped of the marriage she believed would last forever. Though the relationship was changed, her concern for Ernest eventually outweighed her anger and loss. Just as when the city loses the leaves from its trees along the pathways within the Palais Royale, this period of Hadley's life must have been tragic for her, and still remains so for those who have been left behind from love relinquished.

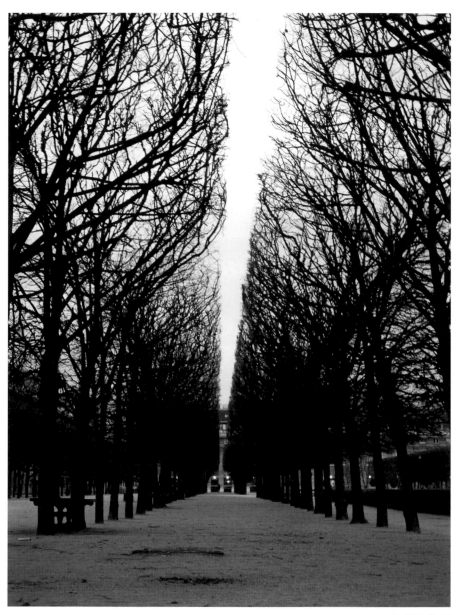

Le Palais Royal

Banished. While awaiting divorce, Hadley spent her days and nights inside this small hotel room, six flights up, within its inwardly slanted walls and its barred windows. How confined Hadley must have felt, with her young son, looking out over the iron rails and contemplating her role in the demise of her marriage. From the window, she could see the Avenue de l'Observatoire, and the Notre-Dame-des-Champs side street where she and Ernest once lived above a sawmill. Looking slightly left, she could see the Closerie des Lilas, where Hemingway penned perhaps his most famous short story, "Big Two-Hearted River." And ironically, in front of the Lilas, she could see the Marshal Ney statue—the very monument Ernest admired because it symbolized loyalty. This was Hadley's final view of their city as her marriage came to an end.

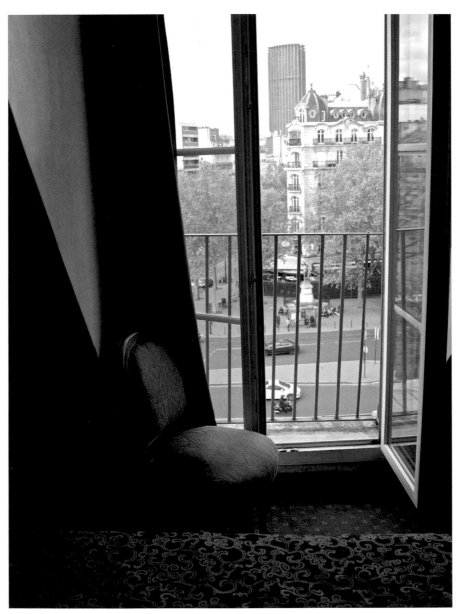

Hadley's room, Hôtel Beauvoir

Leaving from, or returning to, her room in the Hôtel Beauvoir, Hadley passed this striking piece of sculpture set against the grey, lightless sky. For her, it might have been a constant reminder of being let go. Of no longer being held in the arms of her love. Hadley had been devoted to Ernest. She had admired, loved, and supported her husband unconditionally. For Ernest, this sculpture might signify his betrayal of a remarkable woman, the collapsing of a relationship that once nurtured the creative spirit within him. Walking in Ernest Hemingway's footsteps through Paris, one can learn great lessons. Lessons on inspiration. Lessons on craft. Lessons on influence. And, lessons on love.

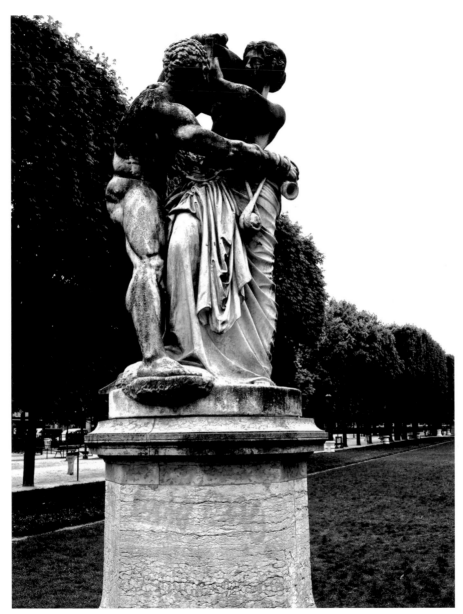

Jardin du Luxembourg

The final dark blow loomed large for Ernest and Hadley . . . their divorce. The Fontaine de Médicis, in the Jardin du Luxembourg, is set along the path that once shortened the walk Ernest took home to his love. The weight of Hemingway's success spilled over into his once uncomplicated world, and fame made him larger than life. This is the story set in Paris that has been written and lives within the pages of Hemingway's *Feast*. This is the memoir's true height, and this is the story that breaks the hearts of its readers.

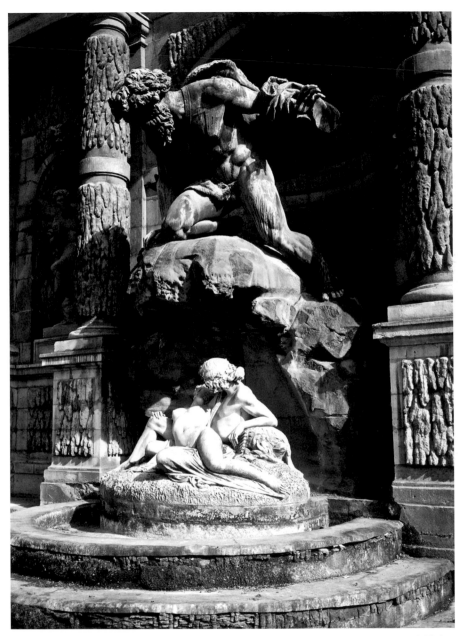

Fontaine de Médicis

Words written on divorce decrees of those that wandered into the arms of another were official and few.

Alienation of Affection.

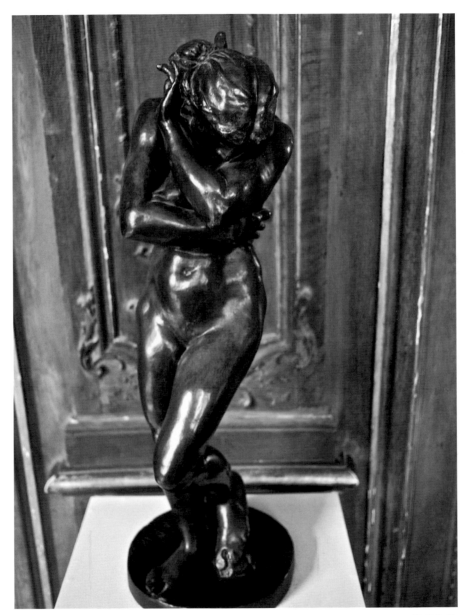

Rodin's *Eve*

Knowing that Hadley was, in so many enduring ways, as responsible for his first novel as she was for his first son, Bumby, Hemingway left them with a lifetime of support through the royalties from *The Sun Also Rises*. Ernest believed this might lessen the hurt he had caused them. This generous and sensitive act speaks not only to his confidence in his writing, but also to his honor and gratitude to Hadley for her unyielding support, encouragement, and love during those early years together.

Hôtel George V

In the end, it was Ernest, not Hadley, who lost. Mostly, because in Paris, on January 27, 1927, he let go of Hadley's hand. People say that behind the façade of those who seemingly have it all, often lays unhappiness and discontent. After leaving Paris, and throughout the rest of his life, Hemingway appeared to have everything—fame, money, relationships. What lay behind it all, however, in 1961, upon his return to Paris through his memory, was a depressed and apologetic man who knew well that Hadley was the only reflection of everything he found to be true and noble in himself.

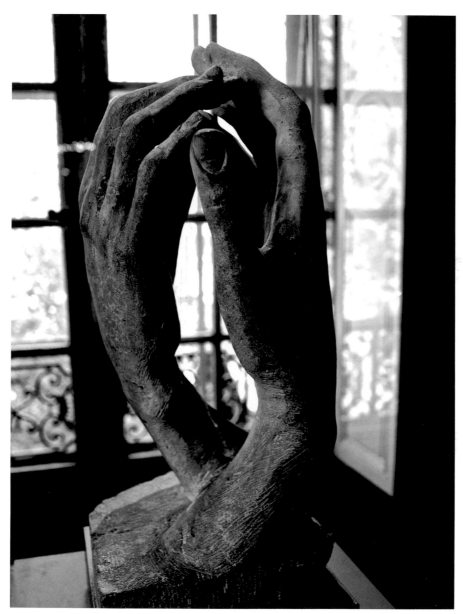

Rodin's *The Cathedral*

Hadley, dedicated to her husband, left St. Louis and went eagerly to his Paris. She was not an artist, but she had tried her best to fit in with his creative life and artistic friends there. When the marriage ended, she stayed in Paris for some years without him. Being married to Hemingway had been a big responsibility. Once through the trauma of divorce, she found she was able to manage on her own and create a pleasant and calm life, free of resentment. She once said to him, *Imagine my ever having thought there could be any bitterness between us—there never will be because my heart works the other way toward you.* In years to come, in letters she and Ernest would write to one another, she always seemed to find encouraging remarks with which to leave him. Hadley would end her letters with the words, "Eat well, sleep well, keep well and work well."

Louvre, *La Sieste*

By his own admission, Hemingway's fall from grace began when he left his wife and child. He had everything in Paris and everything in Hadley. In those years together, he was productive, energetic, and happy. Upon the nostalgic return to Paris through the writing of *Feast*, Hemingway acknowledged the sad truth . . . that he wished he had died before he had ever loved anyone but Hadley.

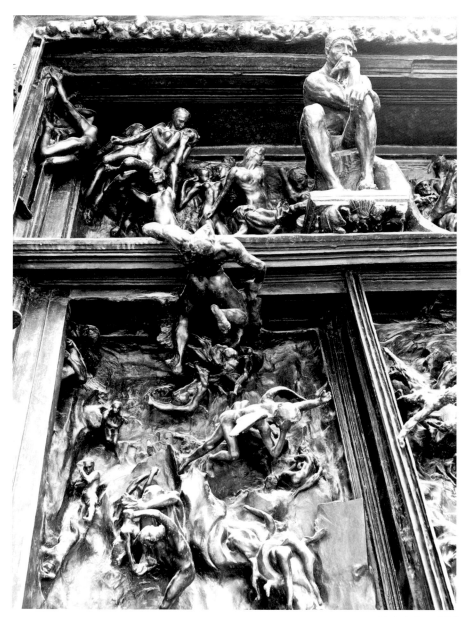

Rodin's *Gates of Hell*

It is lovely to know that Hadley, who Ernest acknowledged as having held no blame whatsoever in the break up of their relationship, rallied and went on to have a long and meaningful second marriage. She met and fell in love with a man who shared in her passion of the outdoors through hiking, bird watching, and gardening. It is bittersweet to know that Ernest, after three consecutive marriages, had the courage to acknowledge Hadley's happiness and admit that she had married a better man than he. Like a bird perched on a thin stem, Hemingway was seeing and learning how fragile, yet powerful, marriages can be.

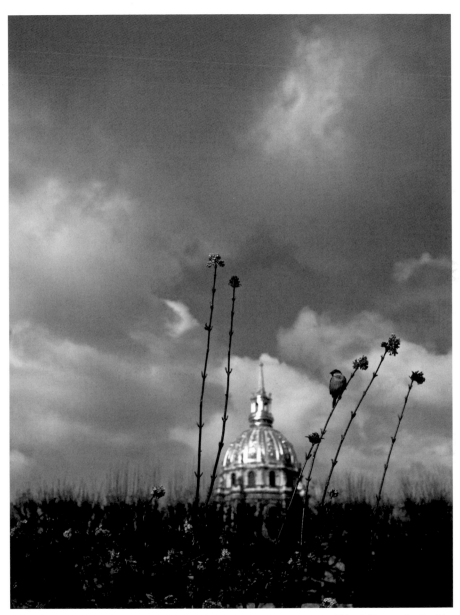

Eglise la Dôme at Les Invalides

Hemingway's own reflection can be seen in many of the great statues that are found in the Jardin des Tuileries. In this statue, of an aimless and lost man, he may have seen the reflection of shame and of a man who knew he would have been a better husband had he made more selfless decisions. Sadly, Hemingway came to this truth too late in his life. In the end, there was no *one,* or any *thing,* that would help him overcome his regret of leaving Hadley in Paris.

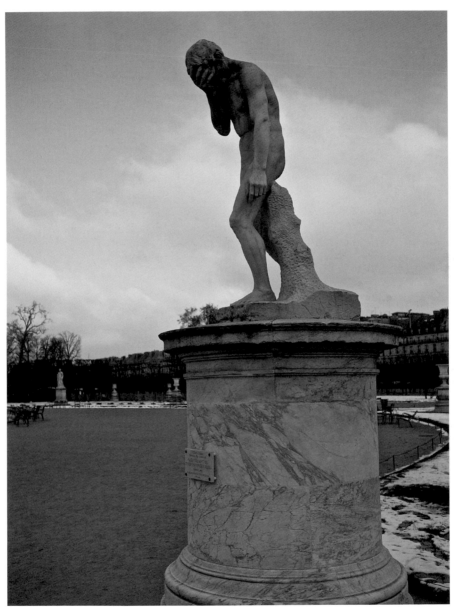

Jardin des Tuileries, *Cain*

Love. Looking back upon his life, Ernest Hemingway said that Paris was the city he loved best in all the world. He wrote that when he and Hadley were young there, nothing was as simple as it had seemed. He believed that nothing—not being poor, not having sudden money, not the moonlight, not right or wrong, not even the breathing of someone who lay beside you in the moonlight—was simple in the City of Light. In the end, Hemingway found himself alone there. Alone in the city where he and Hadley were once in love with one another, and where they were very happy.

Courtyard off Rue de Rivoli

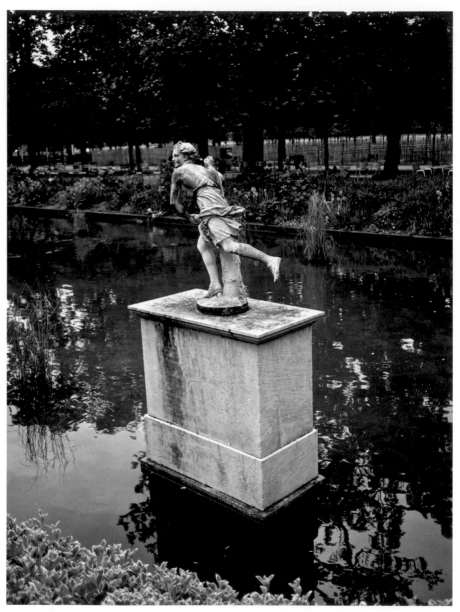

Jardin des Tuileries

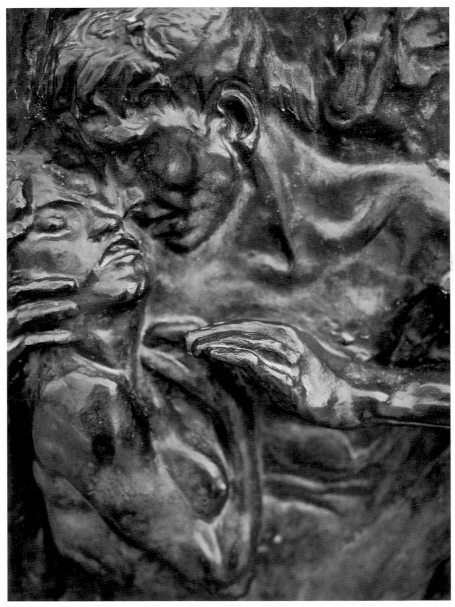

Rodin, *The Gates of Hell*

V

Invitation

A Few Places to Consider While in Hemingway's Paris

Paris wishes to be seen, experienced, and remembered as a city that has weathered the numerous elements of time beautifully. The modern world, no matter year or invention, accepts its place . . . seemingly bowing to this historically profound city. Scholars, for decades, have missed seeing and feeling the Paris that surrounded Hemingway in the early 1920s. They claim his city is gone. But this claim is not true, and if the visitor chooses his steps carefully by moving away from worn paths and walking close to the water's edge and down quaint side streets and through open doors and up winding stairwells and looks out of windows and stands upon balconies and sees with fresh eyes the avenues and boulevards and rooftops and cafes and restaurants and gardens and statues and fountains and museums that fill this city with wonder and significance–then, he touches the past through the present and can feel the city that inspired Hemingway and the city that presented for him a concentrated and artistic education. In the spirit of Hemingway's famous iceberg metaphor, the following few pages present the visitor with yet one-eighth of his cherished Paris . . . with the hope and the promise that one *feels* the remaining seven-eighths.

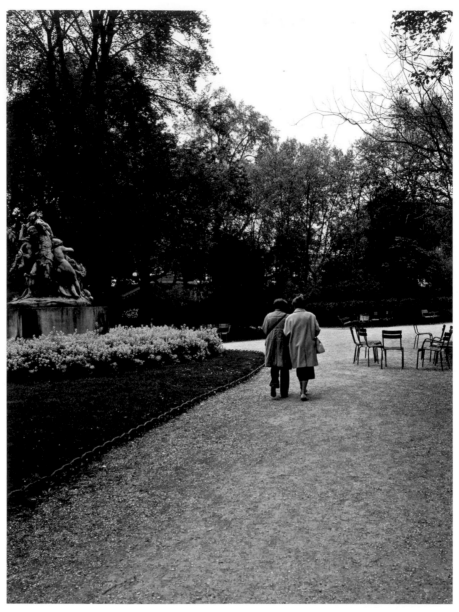

Jardin du Luxembourg

The Walks . . .

In Paris, destinations are filled along the way with small, serendipitous images. Whether walking in solitude or with someone, the city's enduring physical beauty will surprise and imprint itself upon one's memory. Hemingway used the city, its boulevards and streets and pathways, to both inspire and compose himself. Life as a young writer surrounded by the Modernist experiment was challenging. The loveliest walks, those that easily conjure up impressions of Hemingway's city, can be experienced in the Luxembourg, the Royal, and the Tuileries gardens. Very little has changed over the decades within these gardens, and much of the landscape reflected in Hemingway's prose is gained by a simple stroll. Hadley, too, used these gardens, just blocks from her Left Bank apartment, for the fresh air and vast space they afforded both her and Bumby. The walkways along any part of the Seine, and the circumnavigating of the Île Saint-Louis, present yet further opportunities to connect with the past. Walking throughout this city, under its dramatic sky, is always significant and is symbolic of Hemingway's time in Paris.

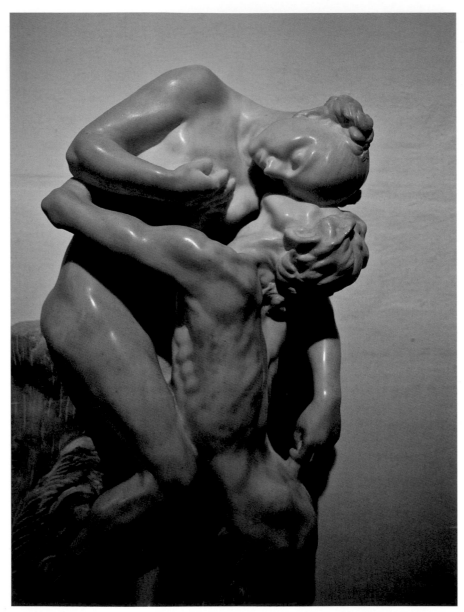

Rodin's *Camille Claudel*

The Museums . . .

Hemingway was learning and absorbing so very much while enveloped in the hallways, and in the art itself, of the many museums and salons that dot the landscape of Paris. To create human emotion on canvas or through stone, moved and touched Hemingway. Like Rodin's sculptures, Hemingway's prose, once chiseled down, was simple and direct and emotionally powerful. These museums became classrooms for him. The Louvre, with its lavish and impressive collection of the Masters, stood as a strong foundation to Hemingway, while the d'Orsay, with its Left Bank prominence, reminded Hemingway of the endless possibilities of artistic expression. And, situated quietly behind the d'Orsay, on the lovely Rue de Varenne, is perhaps the most romantic of all museums in Paris, the Musée Rodin. Once the home and workplace of Rodin himself, the visitor cannot help but feel like a personal guest of this magnificent sculptor. Expressed in stone and bathed in natural light, Rodin's art stirred Hemingway's mind while elevating his prose. Hemingway knew well that within art, all subjects and disciplines were revealed.

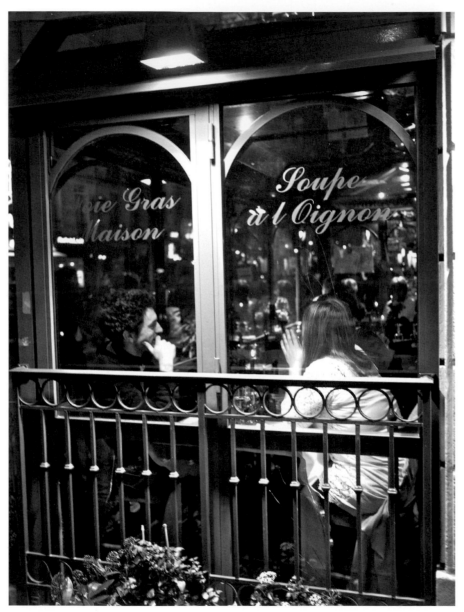

Left Bank restaurant

The Cafés, Restaurants and Bars . . .

Much of Hemingway's work was framed from within the many cafés, restaurants, and bars that line the streets of Paris and whose tables cascade onto sidewalks. To breakfast at La Dôme or Café de Flore, to lunch at La Closerie des Lilas or Brasserie Lipp, to dine at Lapérouse or Le Tastevin, and to drink at The Bar Hemingway located in the Ritz or the Bar 228 at Le Meurice is to see people and activity from the proper distance and through Hemingway's frame. A fondness for good food and drink, and a desire for the right and true setting from which to observe and document life, was a strong and lasting requirement of Hemingway's and one he greatly coveted. With such variety from which to choose, any place is right and memorable and very much in keeping with Hemingway's requirements, as long as it contains the proper lighting, polished service, the best of food and beverage, and, if one wishes to write one's own true sentence, a pen and blank sheet of paper.

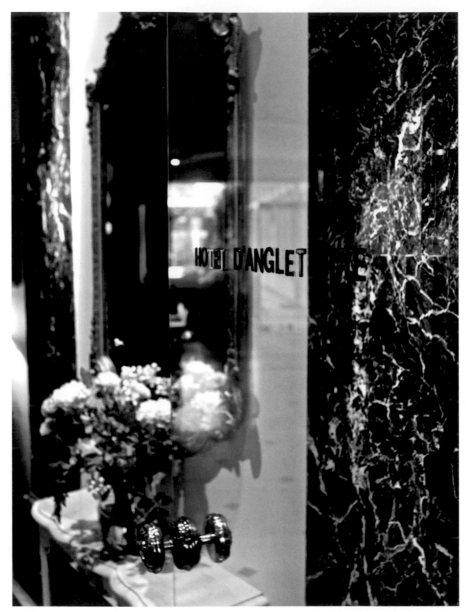

Hôtel D'Angleterre

The Hotels . . .

If the composition of a sentence must work to express a complete thought, then the composition of one's hotel room must allow that thought to present itself. For Hemingway, hotels were an extension of the cafes, and he would use them for writing, collaboration, celebration, consumption, escape, and even to inspire setting, as in his short piece, "Cat in the Rain." One needs an atmosphere that is simple and clear and clean, and that is sympathetic to the complexities of the traveler and of this city. For Right Bank hotels, one will do well by checking into the regal Hôtel Brighton or the historic Hôtel du Louvre or Hemingway's coveted Ritz, as each keep one close to his Paris. The Left Bank, where Hemingway lived with his adoring wife, Hadley, has the artful Hôtel de l'Academie Saint Germain and the enchanting Hôtel Melia Le Colbert and, still thriving, the first hotel where Ernest and Hadley stayed in 1921, the Hôtel D'Angleterre. These hotels present one with the peace of mind necessary to process the reflections and thoughts that, at the end of a day, swirl around this city and around Ernest Hemingway.

Page from my journal

Epilogue

This is a love story. *A Moveable Feast* was written by a man who was trying to tend to the delicate threads of his life–the threads that joined him to his craft, to those who influenced him, and to the woman he loved most. His writing and his Hadley, each were there in the beginning and each would be there in the end. No other city in any of his travels was as significant, professionally or emotionally, as was Paris.

And it remains there. All of the complexity, beauty, and intrigue that Hemingway described within the pages of his memoir . . . it is all still there in Paris–there for you, to experience for yourself.

It is my hope that through my photographs and through the journals I have kept, I have given original and authentic testimony to the artistic triumph and personal tragedy in Ernest Hemingway's City of Light.

Acknowledgments

There are many who are not seen, but I hope are felt, that have contributed beautifully to this book. I wish to thank my mother-in-law, Katie Wheeler, for the passion she instilled in me to travel this world, and especially travel to her beloved Paris. Thank you to my father-in-law, Dr. Douglas L. Wheeler, for his unyielding academic guidance and moral support. My parents, Robert and Gloria, have also been nothing but supportive and encouraging and loving . . . thank you. Then there is my friend and mentor John Robinson, who helped inspire this book and who helped edit my prose along the way; my artistic friend, Amy Palmer, who helped develop and sharpen my writing style; my dear friend and technology partner, Jeff McLean; and my friend and fellow traveler, Seth McQueen.

As well, I want to thank my literary agent Peter Riva, his wife, Sandra, and their team at International Transactions and Yucca Publishing. With Peter's advice and perseverance, my dream of becoming a published writer has come true.

About the Author

Since reading his first Hemingway novel in 1986, Robert Wheeler has been a Hemingway enthusiast. Robert was moved by the humanistic writing of the man—a writer capable of transcending his readers to foreign settings and into the hearts and minds of his protagonists. Hemingway and his work have inspired Robert to travel throughout France, Italy, Spain, Africa, and Cuba, where he has sought to gain insight into the motivation behind Hemingway's books and short stories. As a teacher, lecturer, and photojournalist, Robert set out to capture and interpret the Paris that Ernest Hemingway experienced in *A Moveable Feast*. Through his journals and photographs, Robert portrays the intimate connection Hemingway had with the woman he never stopped loving, Hadley, and with the city he loved most, Paris.

Robert currently lives in New Castle, New Hampshire, with his wife, Meme, and daughters, Emma and Helen.

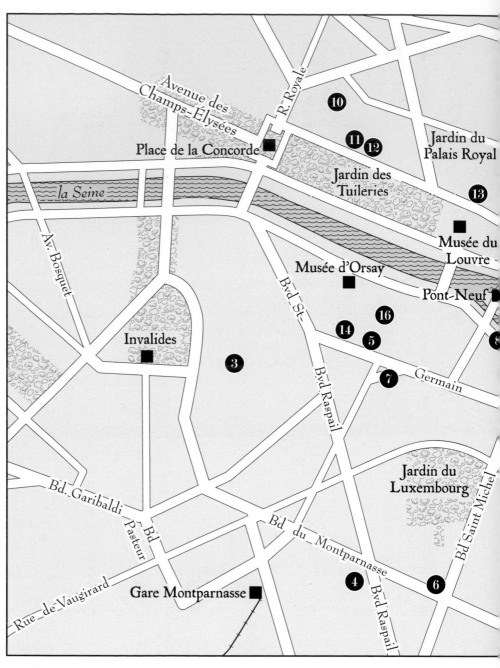

1 Ernest & Hadley's First Apartment
74 Rue du Cardinal Lemoine

2 Île Saint-Louis

3 Musée Rodin
79 Rue de Varenne

4 Le Dôme
108 Boulevard du Montparnasse

5 Café de Flore
172 Boulevard Saint-Germain

6 La Closerie des Lilas
171 Boulevard du Montparnasse

7 Brasserie Lipp
151 Boulevard Saint-Germain

8 Lapérouse
561 Quai des Grandes Augustins

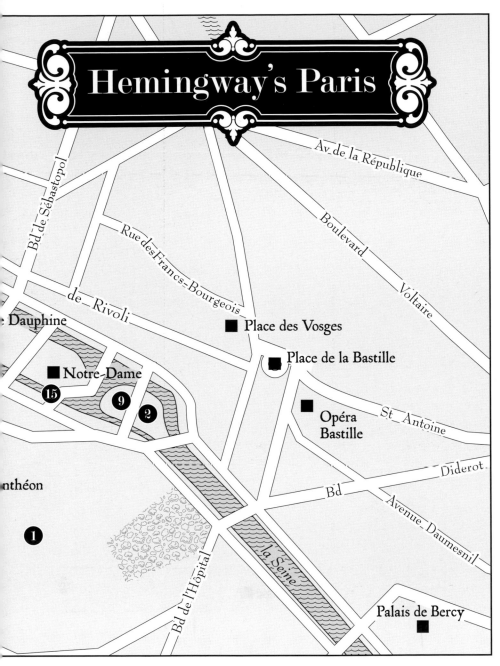

Hemingway's Paris

Av. de la République

Boulevard Voltaire

Bd. de Sébastopol

Rue des Francs-Bourgeois

de Rivoli

Dauphine

■ Place des Vosges

■ Place de la Bastille

■ Notre-Dame

⑮

⑨

②

■ Opéra Bastille

St. Antoine

⑮

Diderot

nthéon

Bd

Avenue Daumesnil

❶

Bd de l'Hôpital

la Seine

Palais de Bercy ■

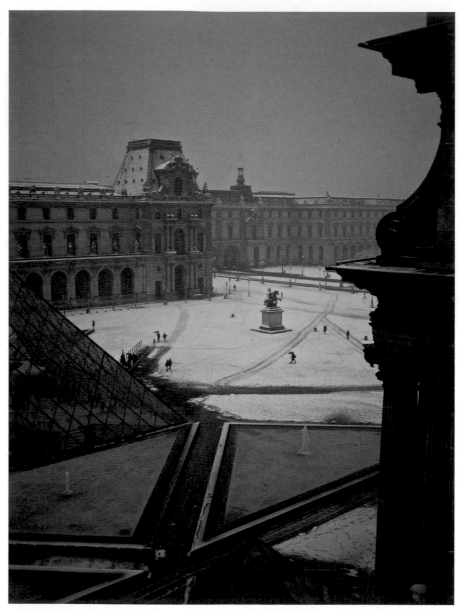

Louvre